Till the Cows Come Home

Dan Nelken

Till the Cows Come Home

County Fair Portraits

KEHRER

Introduction

In farming communities across the United States, the harvest is celebrated annually at county fairs where local farmers showcase their prized produce and livestock. In some places, this tradition has been established for more than 180 years. Family farmers are the core participants in these summer events but their numbers are waning. Agricultural exhibits, once the economic heartbeat of county fairs, are increasingly being sidelined by amusement parks and merchandising interests.

Every summer since 1998, from July to September, I sought out these three-to-ten day county fairs hoping to document through portraits and still lifes, an agricultural tradition that may be in its sunset years. Befriending some of the farming families that participated year after year, I was struck by the fact that both young and old compete not for any significant economic gain, but for the camaraderie and the inner satisfaction of knowing that their year-long effort might reward them with the highly-prized, "Best in Show" purple ribbon. I also learned that some had become "part time" farmers out of necessity, relying on more stable occupations for a reliable income. Not surprisingly, this part-time status did not diminish their dedication to their farming community, connecting them to the rich agrarian traditions of centuries past.

Today, only one quarter of the remaining 2,000,000 farms in America are family-run farms, many of which are struggling to maintain their economic and cultural relevancy while competing with factory farming. In New York State for example, where I took most of these photographs, there are 7.66 million acres of farmland and 47 of the state's 54 counties still hold fairs. These county fairs are representative of rural fairs across the country; the core agricultural programs remain the same even though certain elements of county fairs vary regionally.

Aware that others have looked through a lens at similar subject matter, I did not want to beautify the experience or trivialize it through sentimentality. My love of irony, of circumstance, and of the candor of the moment, guided my photographic journey. I hope that when county fair participants look at these photographs they can say to themselves, "Yes, this is truly how it is."

Dan Nelken
Margaretville, New York

Till the Cows Come Home

All animals except man know
that the ultimate of life is to enjoy it.
Samuel Butler

If you really want to know the United States, get off the interstate. Now. Leave the city, take out the map and head for a freeway exit that intrigues or beckons you. It may be the town's name alone that impels you. Or news of a particular local event. Or the recommendation of a particular friend or neighbor.

It was this last circumstance that brought Dan Nelken to abandon his New York City studio one summer weekend in 1998 for upstate New York. The village he headed for, Walton, New York, was the site of the Delaware County Fair, one of the hundreds of such events that dot New England throughout these warmer months, drawing folks from the farms and villages throughout the surrounding countryside. The city boy in Dan had not really experienced such a fair, but he loaded up his Hasselblad camera with black and white film and decided to give the last day of the fair a try. The photographer in Dan did not come back with a memorable shot that day. But the inquiring, curious and introspective components of Dan made him re-solve to return again in future summers to examine this institution and the people who continued to make it so vital a part of the American experience.

Raised in Chicago and always intrigued by the human parade, Dan Nelken followed his own natural artistic abilities to Pratt Institute in the late 1960s where he sought to major in the graphic arts. In his junior year, however, photography began to draw him away from painting and became his senior major. A Pratt guest lecture by Peter Bunnell, then curator at MOMA, led him to discover the work of

Alfred Stieglitz, Robert Frank and W. Eugene Smith – the latter of whom became a friend and inspiration in future years.

In the next few years Nelken's talent and his ever-abundant energy would take him in a variety of creative directions: as the recipient of many student film awards, as a published photojournalist, and as an exhibition artist by 1971 when Cornell Capa selected him for a one-man show at the Niekrug Gallery. He also produced a significant body of imagery for *Operation Better Block*, part of the New York Urban Coalition, which brought his unique vision to bear throughout the streets of many of the city's most diverse neighborhoods. And while his subject matter ran a wide gamut – from a sensitive portrait of a paraplegic student to a thoughtful study of the Hell's Angels – his perspective remained unfailingly humane and sensitively recorded.

It is important to realize that, even has his work transitioned more into the commercial field, he never lost his creative edge or his interest in the human equation in all that he would witness. He continued to pursue independent areas of interest that became significant portfolios themselves: a colorful portrait of the Jersey City Welding Company; his elegant *Bathtub Series*; a whimsical landscape series (that came about when he made his weekend home in the upstate New York town of Margaretville); and an entirely different but very insightful series on *Anger*. Throughout this mixture of styles and subject matter, however, he never lost sight of the fact that people remained at the core of all the worlds he chose to experience and reveal. The best artists are those that challenge themselves ceaselessly and in this respect Dan Nelken remains one of contemporary photography's most significant and relevant artists.

In Nelken's case the process remains richly in place with his *Till the Cows Come Home* series. Instead of giving up with the first rolls of black & white imagery that he secured in Walton back in 1998, Dan returned to the Delaware County Fair the next year, as well as to countless others. He brought along a separate back for his Hasselblad camera, adding color to his vision. As both he and the work slowly evolved he began – I believe inevitably if one looks at his earlier works – to depict more and more people, finding them playing even greater roles in what started out as purely scenes of objects and places. Eventually the color palette would totally subsume the black & white, which he felt was in danger of becoming too sentimental and romantic for the subject. What started as a single day-long looksee has evolved into a delightful and insightful interpretation of an event and even a way of life that can now be shared and celebrated by all who see his portfolio or take this book to heart.

The county fair is a uniquely American experience which has evolved from a tradition many centuries old when European and Asian agrarian communities would come together to share and celebrate the results of their industry and labor. We know them now by a variety of names – country festivals, expositions, expos, county reviews, agricultural fairs, summer fetes – or by even more specific regional variations, such as livestock shows, fiestas, rodeos or harvest festivals. Above all, however, the county fair was meant as the public celebration of the shared lifestyle of a community and the sense of accomplishment that could be derived from the husbandry and industry that accompanied the life of the farmer and his family.

The resulting record that Dan has brought to us courtesy of his camera and his unique vision is not encyclopedic – nor is it meant to be. He did not set out to

capture every element – from pie-eating to beauty pageants or from animal judging to the product displays – as that would not be satisfying. Rather than trying to cover too much, he has elected to mine the wide variety of subjects in order to provide us with a sense of the rich tapestry of the fair experience itself. While your favorite memory of some past fair event that you would recall or may have read about may not be evident herein, the chances are very good that his images will summon up the sounds, sights, feel and smells (and, yes, there definitely are smells) that are part of the entire county fair experience. Much as Russell Lee and other photographers did in the 1930s with their work for the Farm Security Administration, Dan's initial approach might have seemed documentary or even taxonomic, but that was not where he was heading. The true photographer is one who not only sees clearly and truly but is also committed to learning through the process of seeing and making what he has seen tangible. As Lee's old boss in the FSA, Roy Stryker, once described the process: "Documentary is an approach, not a technic [sic]; an affirmation, not a negation… The question is not what to picture or what camera to use. Every phase of our time and out surroundings has vital significance and any camera in good repair is an adequate instrument. The job is to know enough about the subject matter to find its significance in itself, and in relation to its surroundings, its time, and its function."

Thus Dan Nelken's vision of the county fair is no mere accumulation of people, animals, scenes and events. Far from it. *Till the Cows Come Home* is one of those rare bodies of work that combines a surface ease of viewing with a passionate depth of character and feeling. If one chooses just to enjoy the subjects, then Nelken's images are seemingly direct and uncomplicated portraits of the participants in some of the

hundreds of county fairs that make up American rural life. His vibrant use of color in the square format imagery is combined with the centralized placement of many figures in order to make his subjects emerge from the page with an assured presence of who they are and what role they are playing in each fair.

Simultaneously, however, these photographs also possess a depth that is alluring and compassionate. Nelken's county fairs exist on many levels – as entertainment, competition, communication, celebration, and crucible of human emotion – but above all they serve to provide us the viewers with a point of focus from which we may be provided with the opportunity to share in some aspect of all these experience. His photographs invite us to become an active part of this process of vision, much as Walt Whitman first noted in a related context over a century earlier: "I think I could turn and live with animals, they are so placid and self-contained / I stand and look at them long and long."

Do so. Look deeper into each photograph, past their record of human faces and animal figures and through their delightful wit or wistful pathos. If you do so, the spirit of these participants and the complexity of the seemingly simple events in which they are engaged will move you. You can be taken aback by the variety of expressions found in just a few faces in a beauty contest, or discover yourself suddenly smiling at the absolute grace with which a young girl holds her prize-winning rabbit. Look at the stunning variety of emotions that many simple hand gestures present as they are employed in handling, holding, controlling and caressing various animals. I do love the expression on Miss Madison County's face as she gets ready to go forth and totally conquer the known world. And was there ever a more confident Maple Queen that that of Otsego County, surrounded by her court of

admiring guys and colorful fluffy animals? Each and every photograph seems to possess an assured presence that summons us to look again and again, and with the framing of every image Dan echoes in positive affirmation Guy Davenport's dictum that "Art is the replacement of indifference by attention."

There is more on the way as well. In exploring the texts and stages and display midways of various county fairs, Dan also uncovered a more recent aspect of the scene – the demolition derby. At first this contest of noise, destruction and automotive violence seems alien to the world of homemade preserves, staid agricultural products and young adults affectionately displaying their homegrown farm animals. And Dan's initial style, influenced differently in his recording the furious chaos of such destructive circuses, did take on the edge and immediacy of the events and the crowds watching them. In the end, however, both reflect the independent human spirit at work throughout the county fair and, as such, Dan's vision has become amplified by this newer body of photographs. He continues to reveal a new range of experience and emotion to challenge our beliefs and expand our knowledge. It is almost as if he hears once more the dictum of his old mentor, Gene Smith: "Never have I found the limits of photographic potential. Every horizon upon being reached reveals another, beckoning in the distance. Always I am on the threshold."

As the panoply of the county fair continues to reveal itself to Dan Nelken it remains most important for us to continue to recognize the rich artistry which draws us back again to the *Cows* series. There is a complex lyricism at work in this most commonplace social and agricultural enterprise, as of music that is felt though unheard. The beauty of the real and the poetry of the everyday can only serve to further amplify the importance of the world they reflect. And, as Nelken shares

his photographs and his elegant eye with us he also wishes us to remain ever aware of the fact that the farm, and hence the fair itself, is becoming an endangered species – that there are profound issues to be addressed herein. As he himself has written, "Each county fair lasts from three to ten days. In that period the participants' yearlong commitment culminates in an exhaustive and explosive outlet of self-expression… My portraits are intended to reflect the passion of this truly American phenomenon."

He does even more than that. With an assured heart and a committed sensibility, Dan Nelken unerringly depicts the profound humanity that binds us all and at our core commits us all to participate in life itself. The phenomenon may be uniquely American, but the affirmation is universal.

Roy Flukinger
Senior Research Curator at Harry Ransom
Humanities Research Center,
The University of Texas at Austin

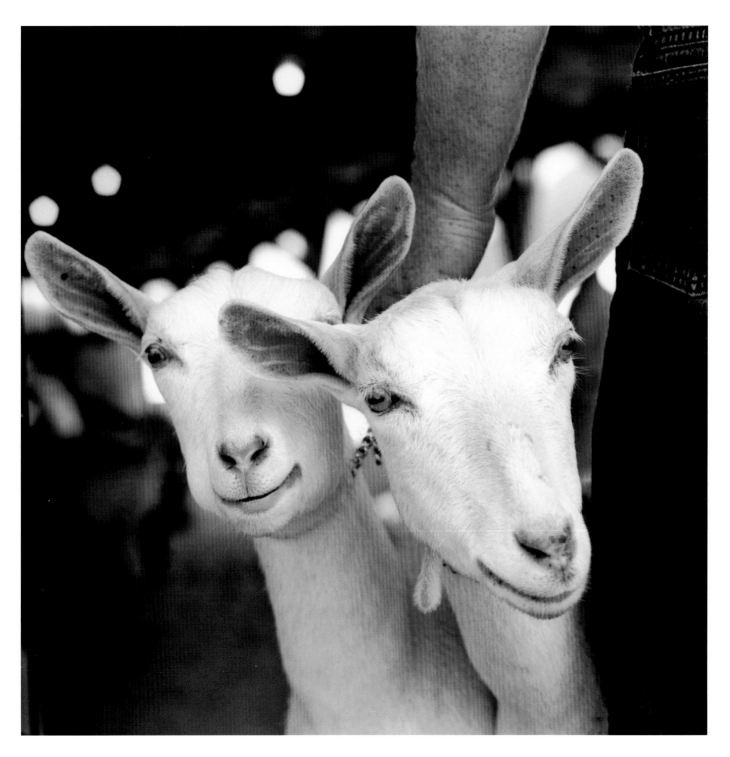

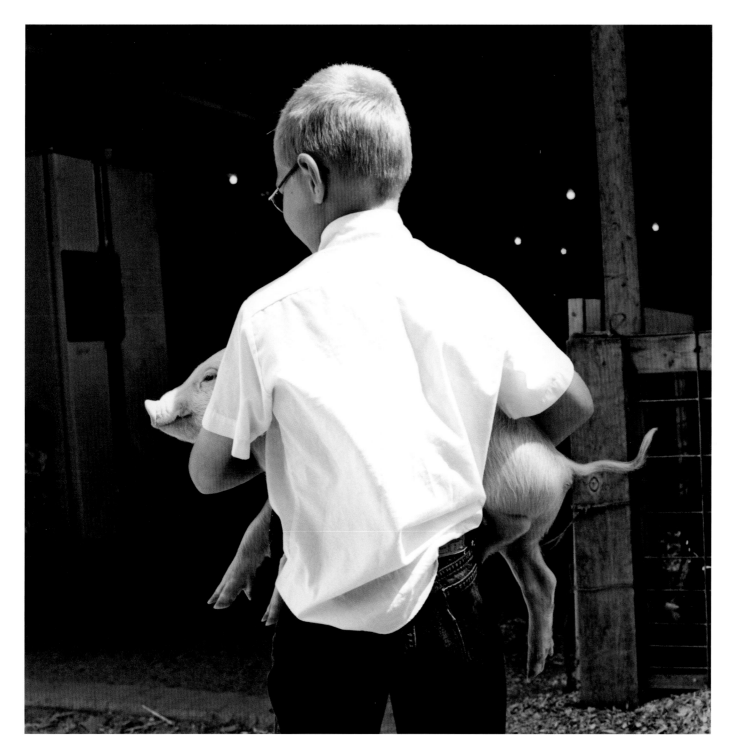

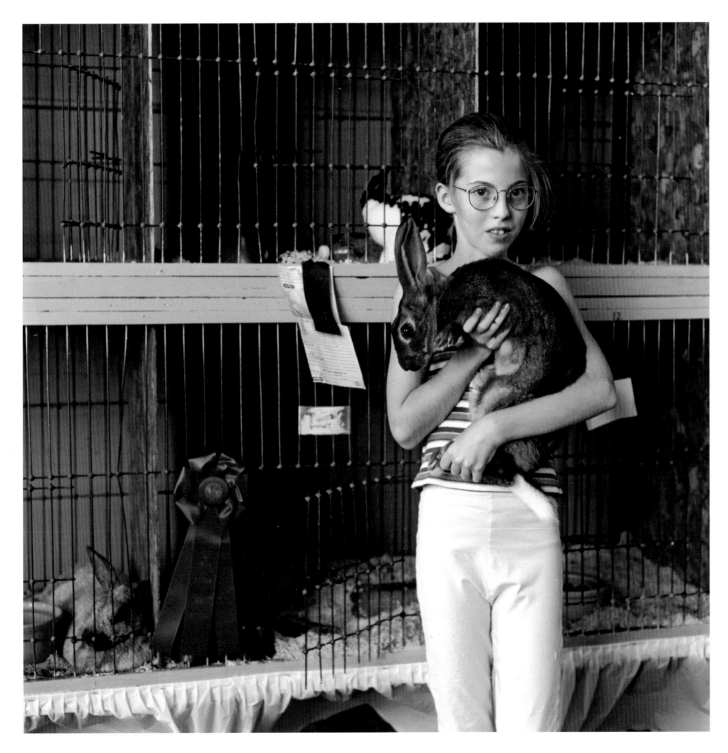

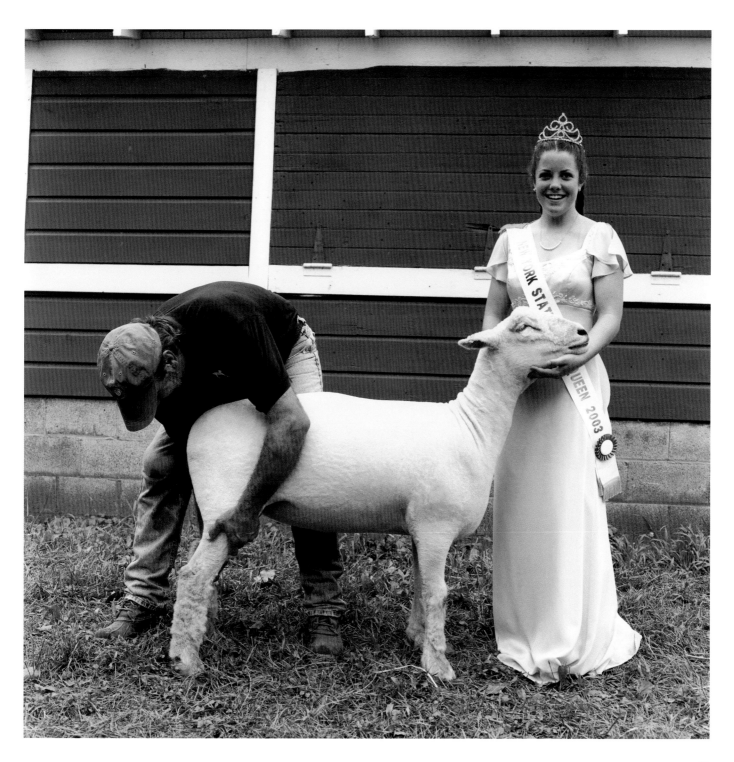

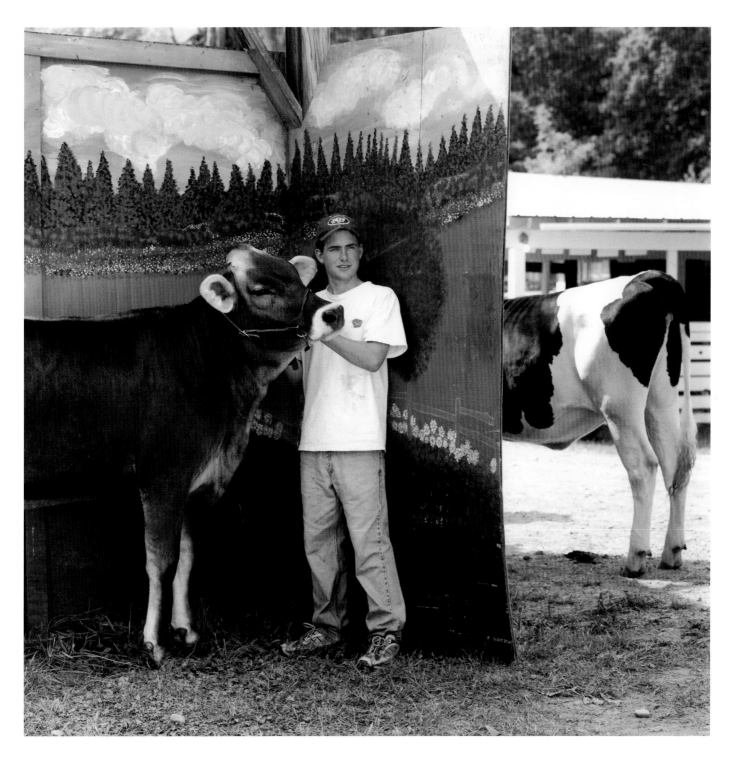

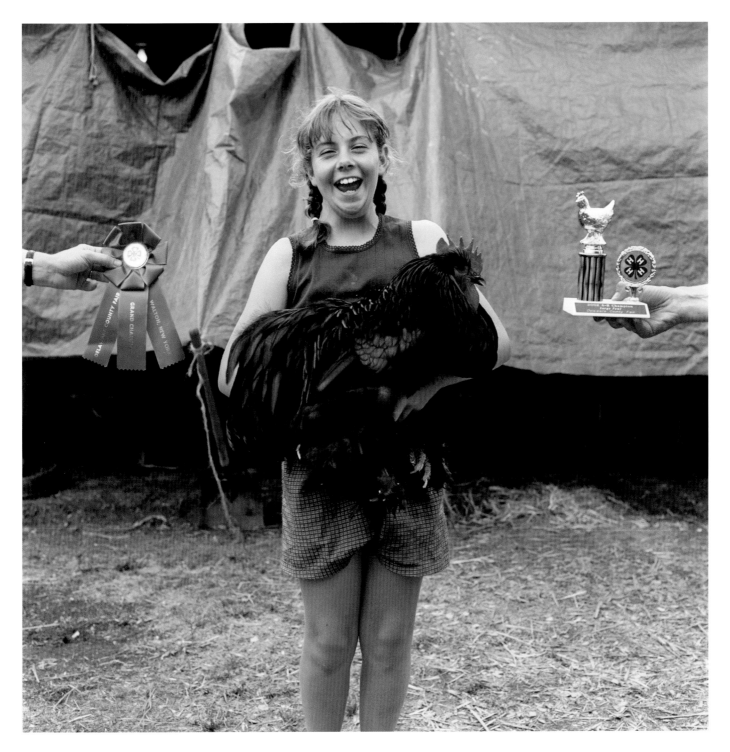

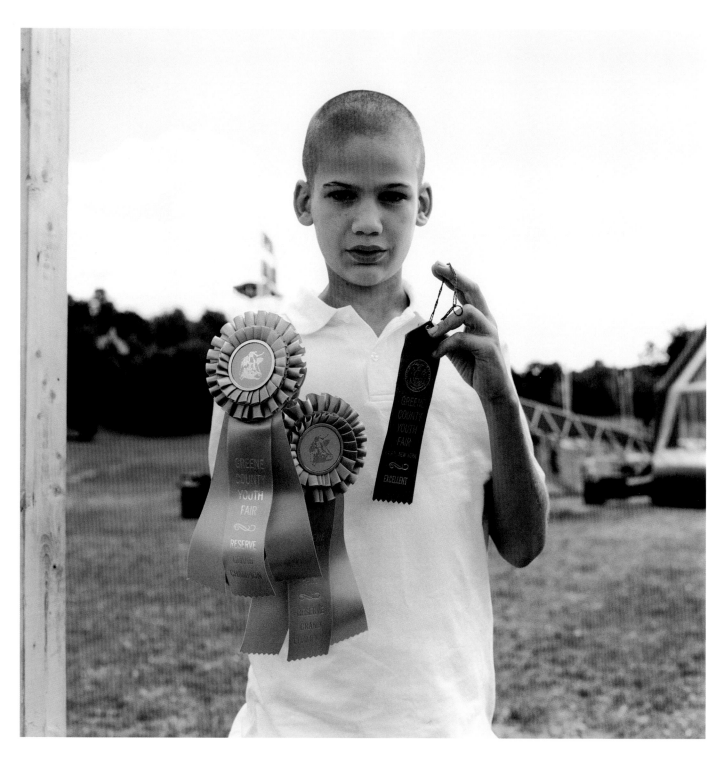

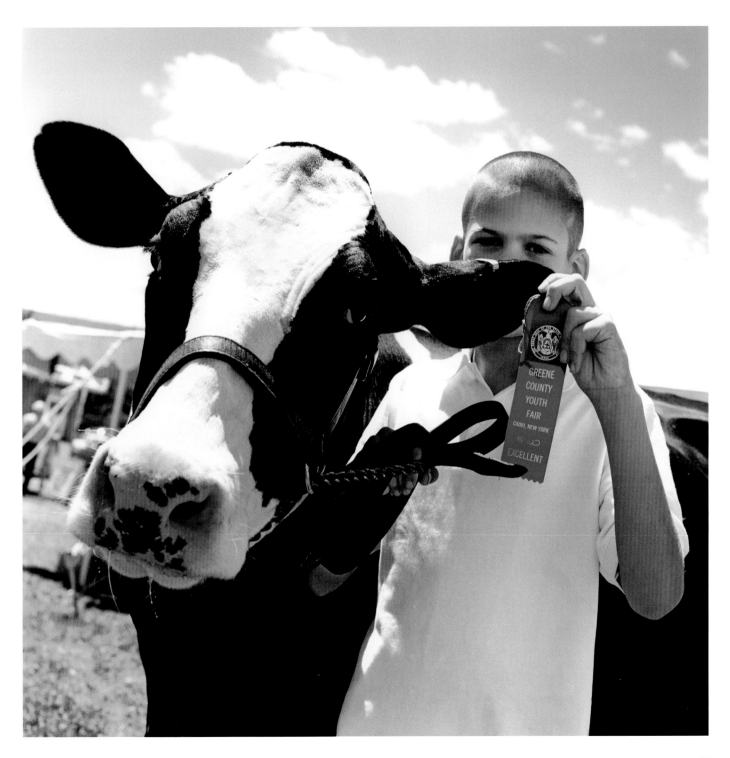

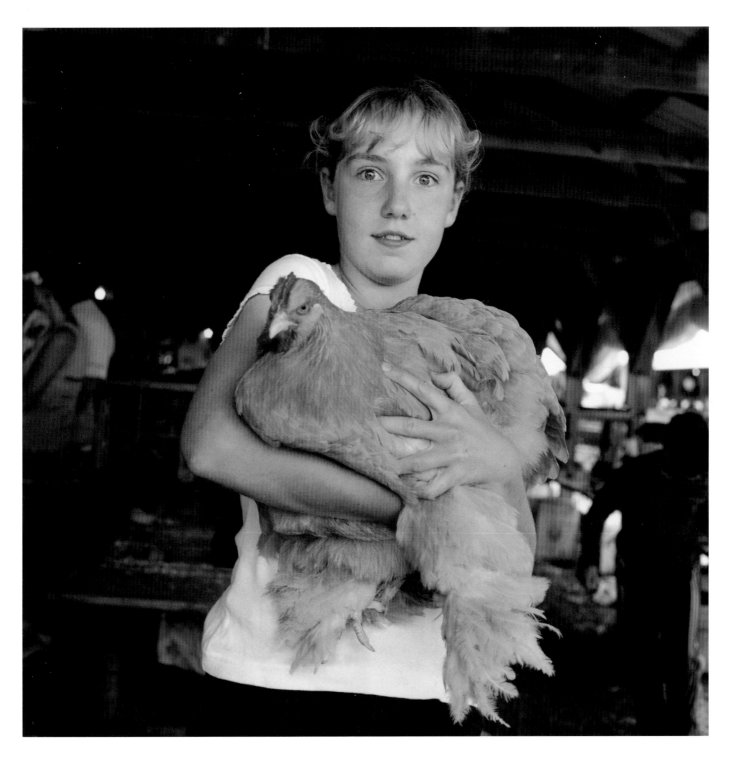

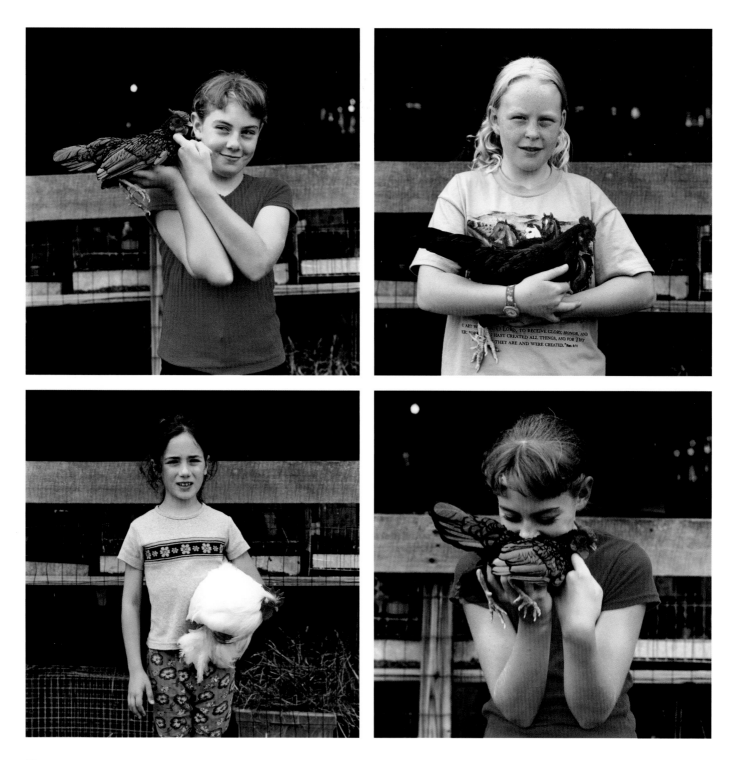

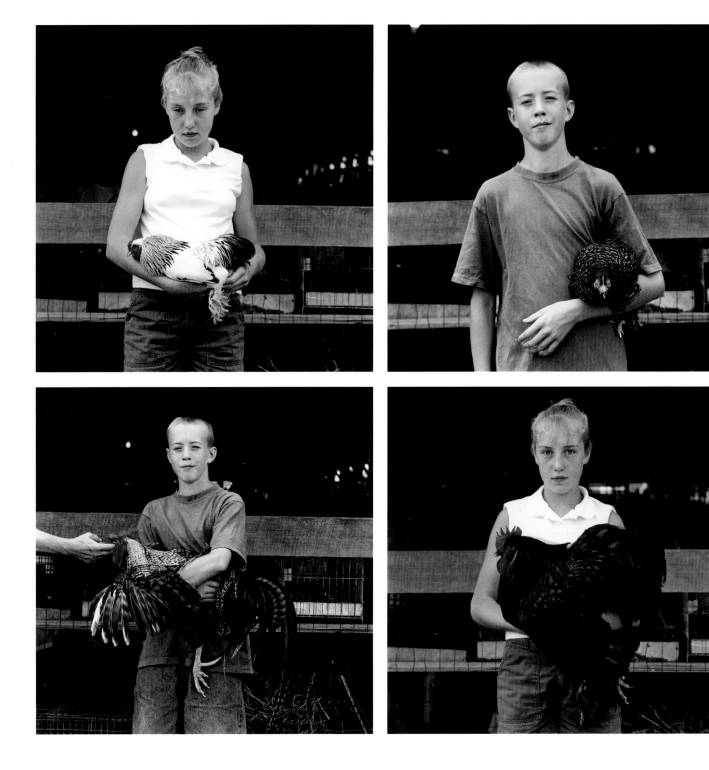

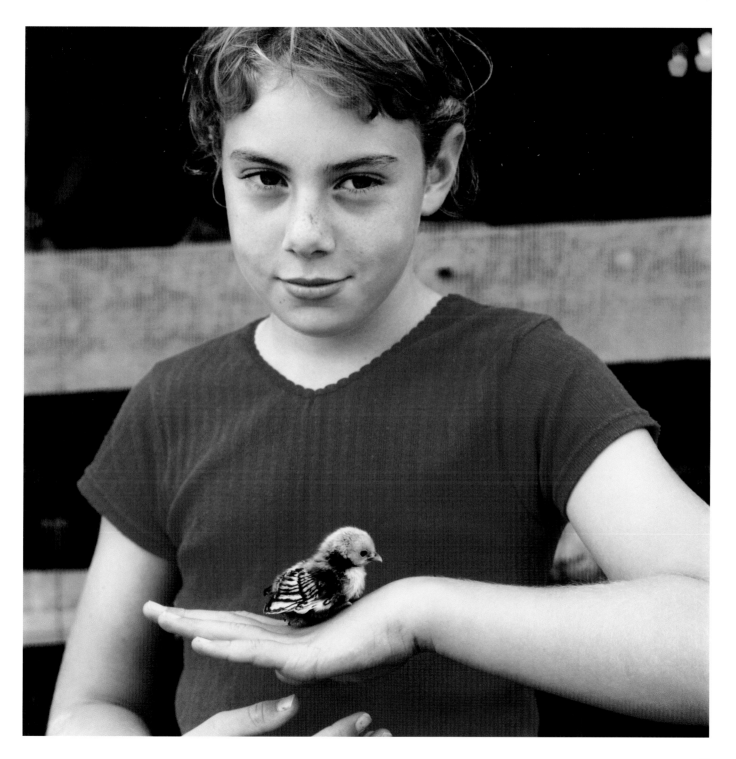

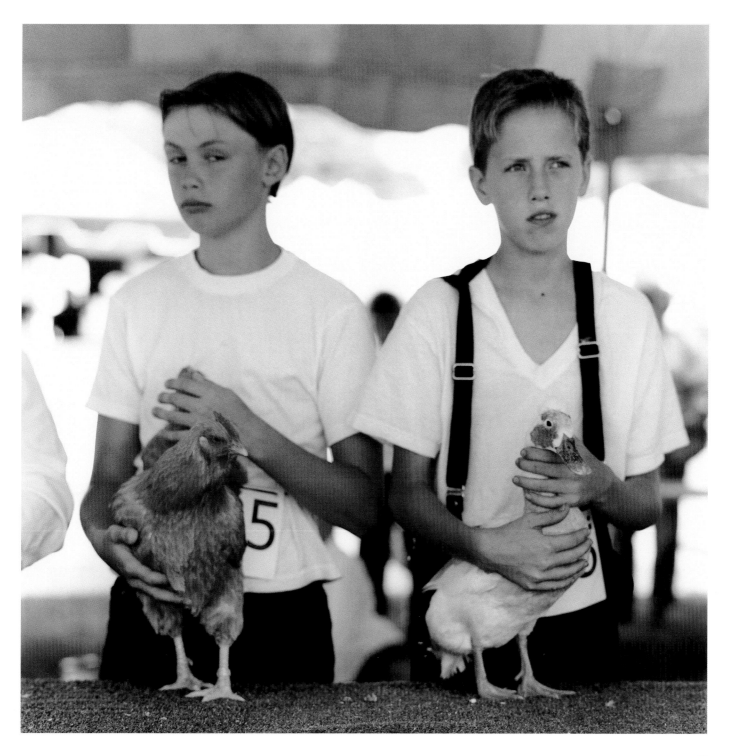

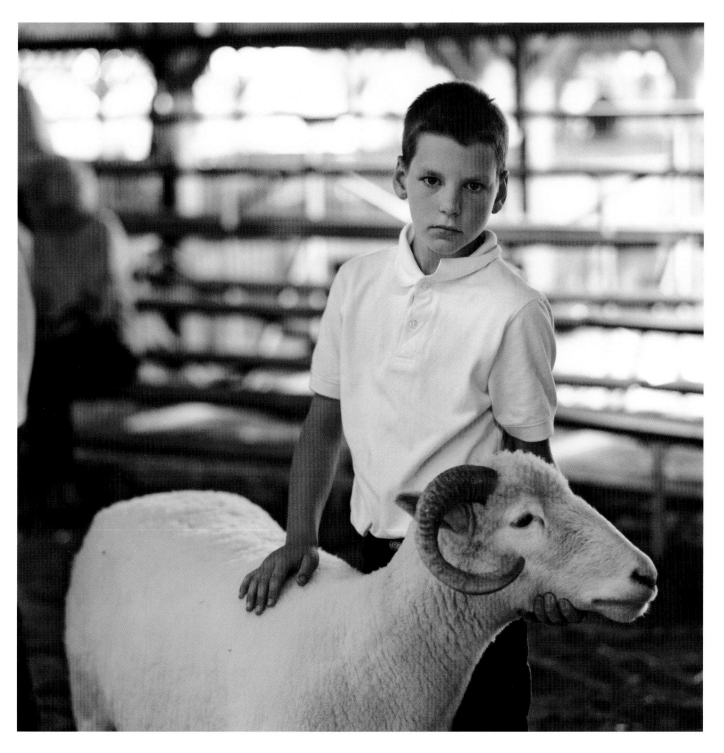

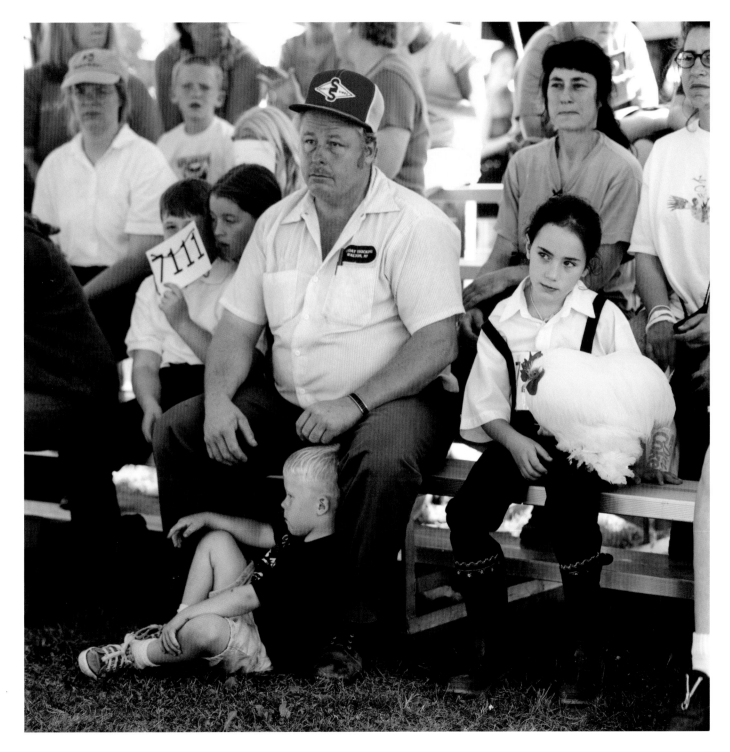

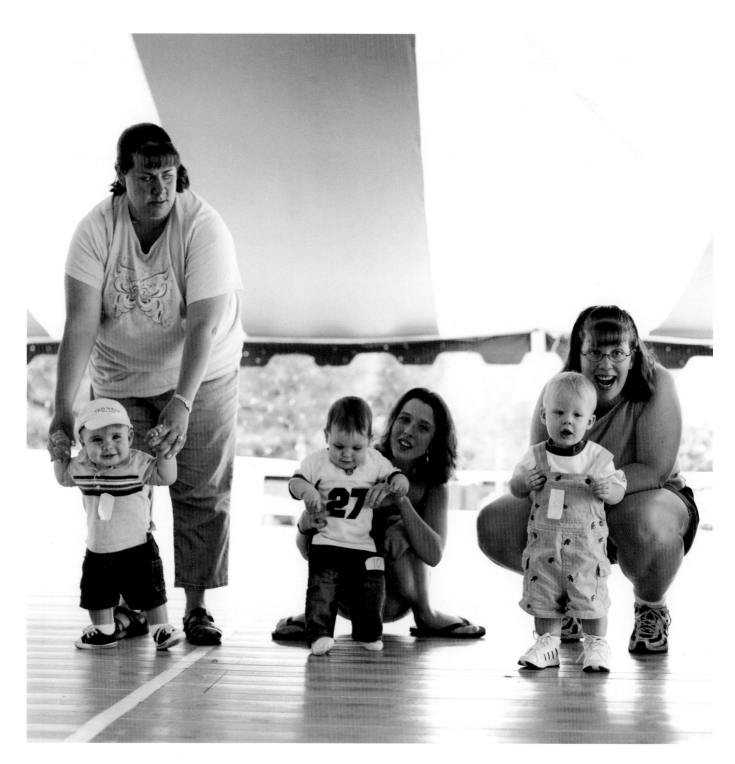

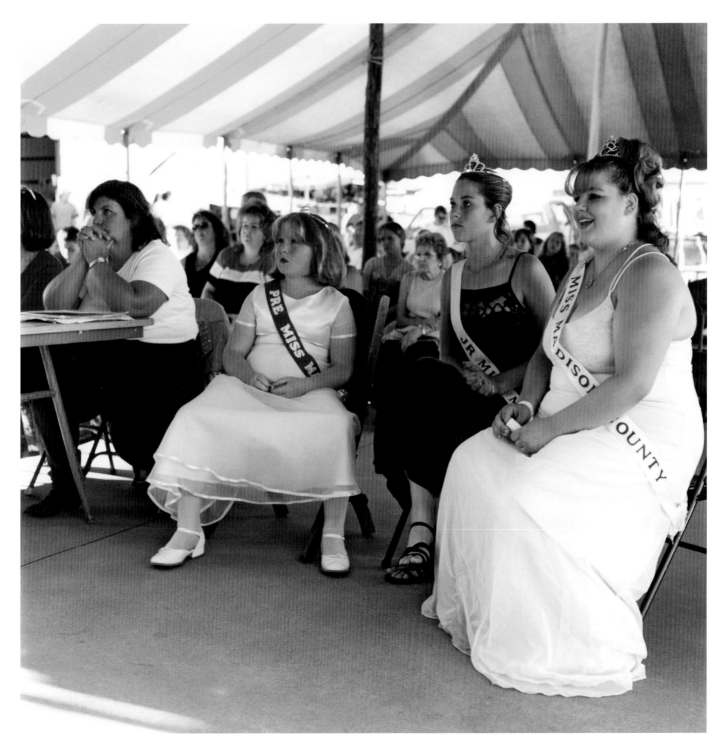

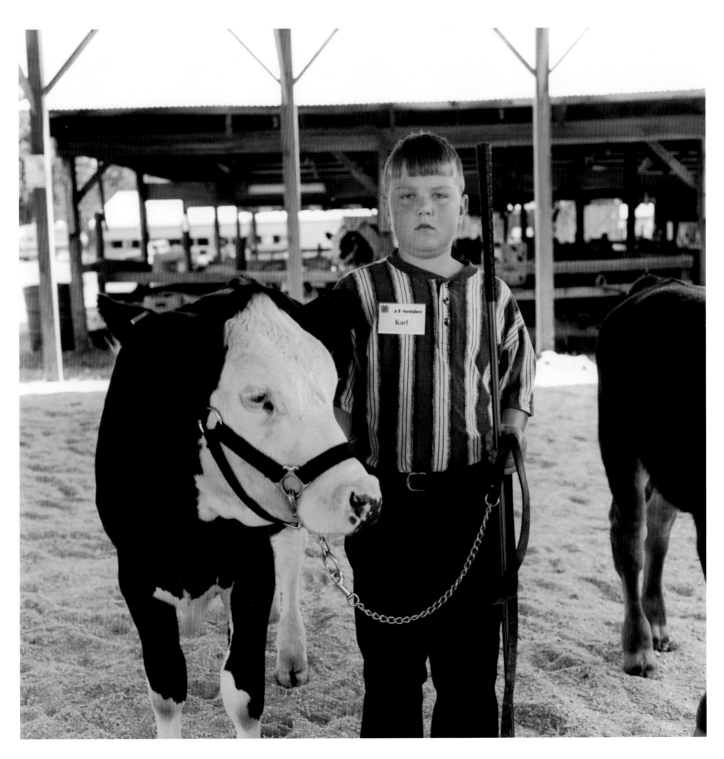

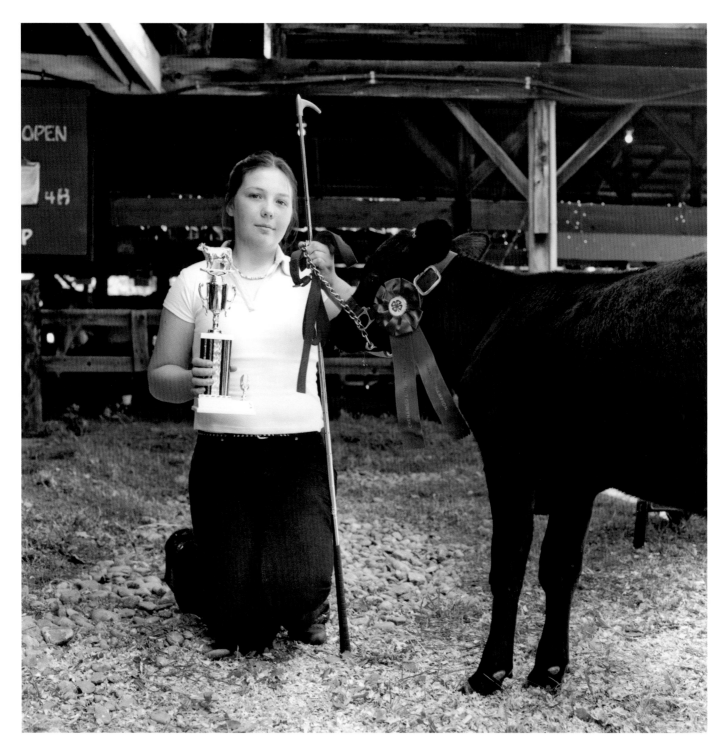

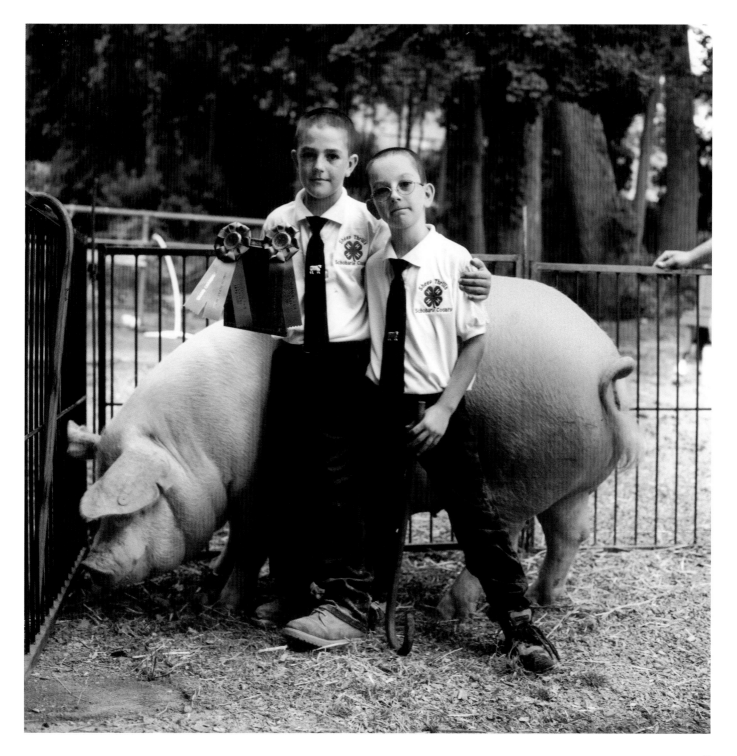

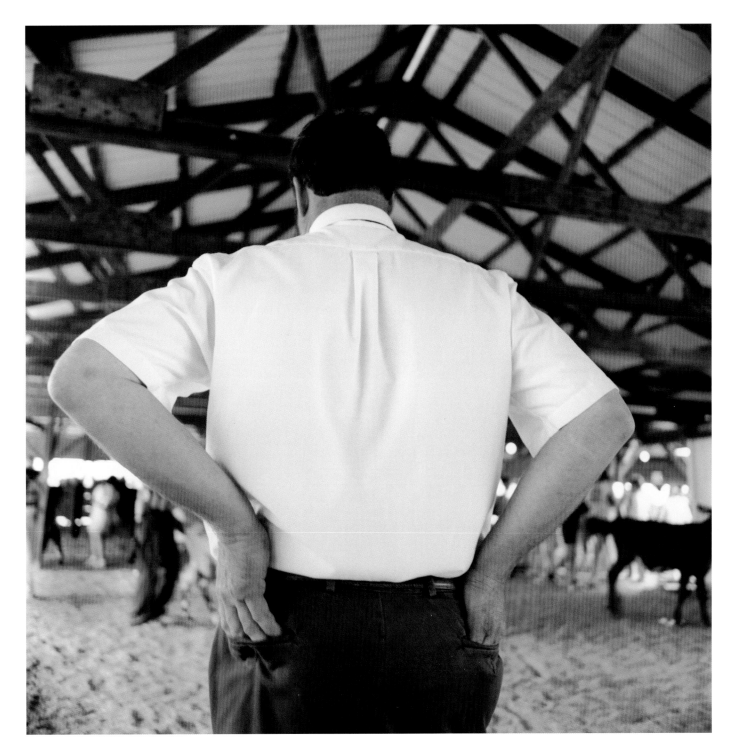

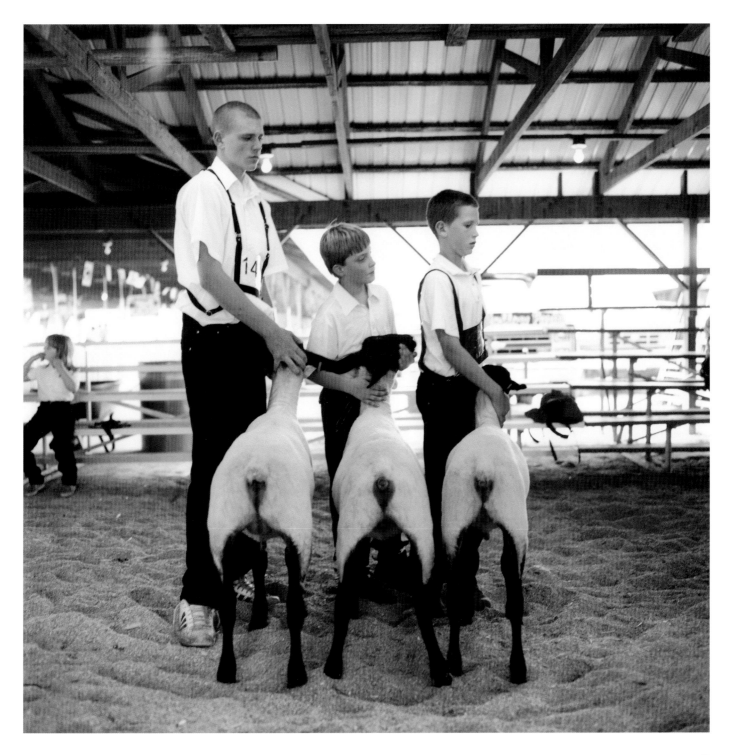

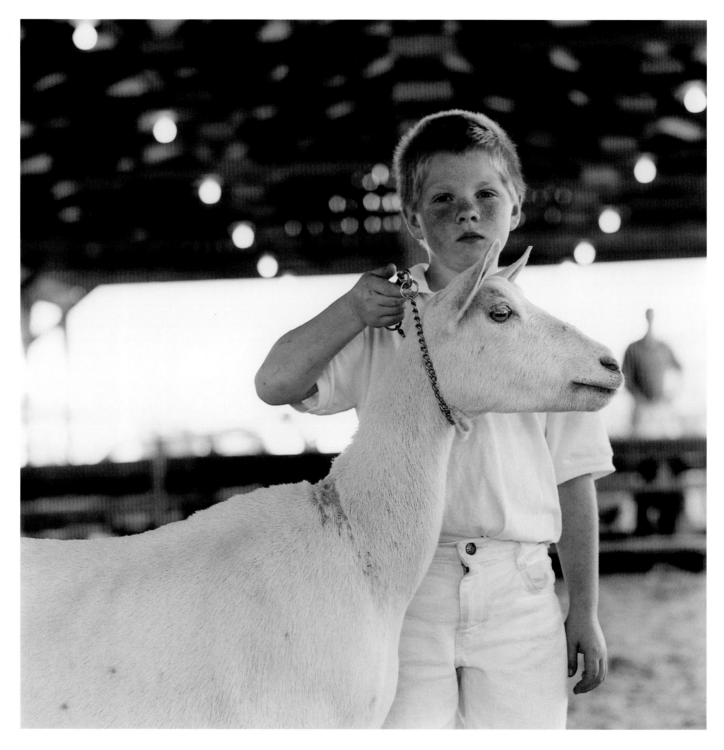

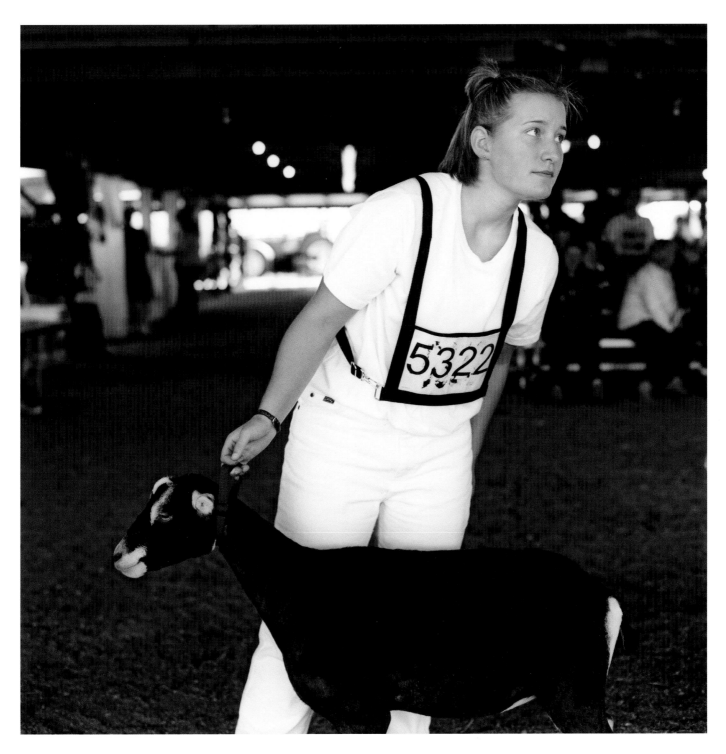

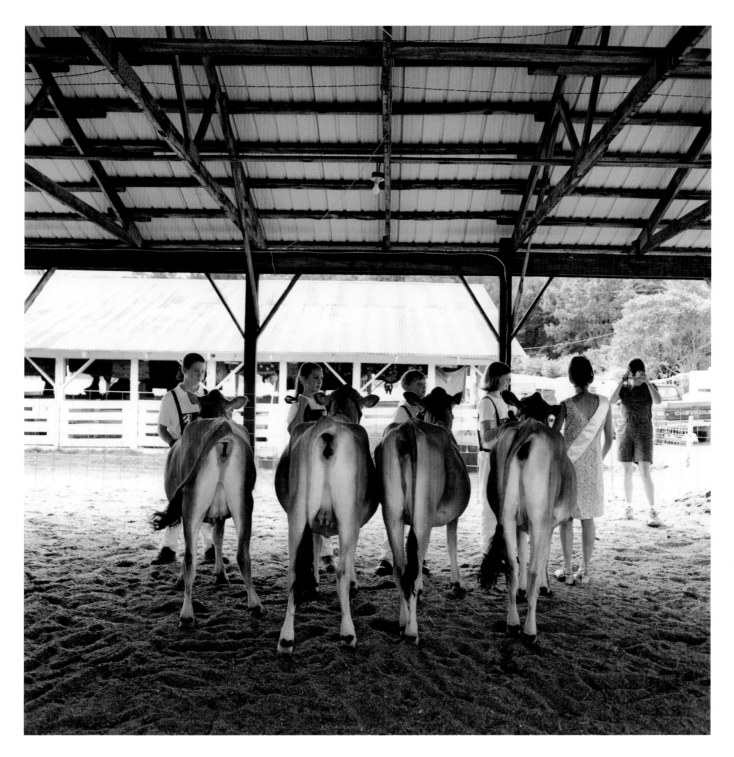

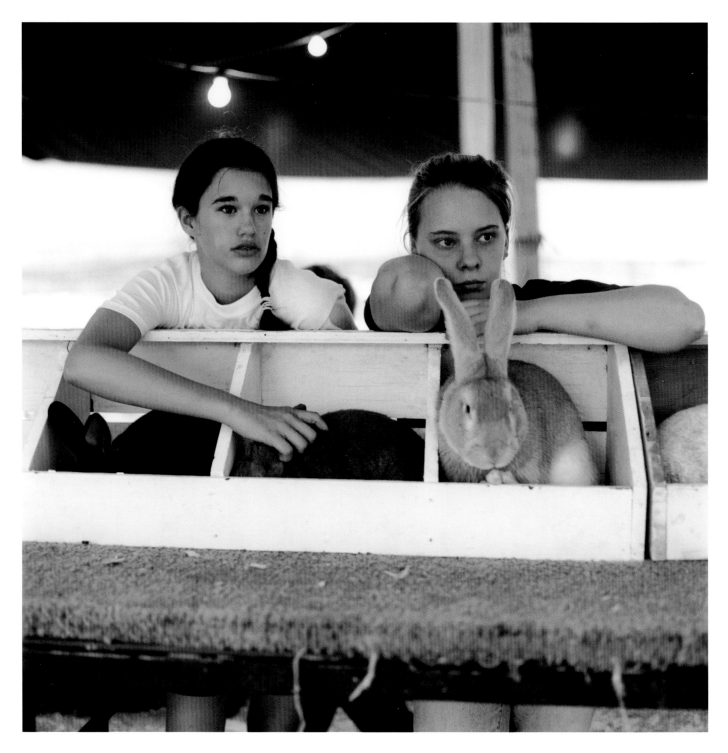

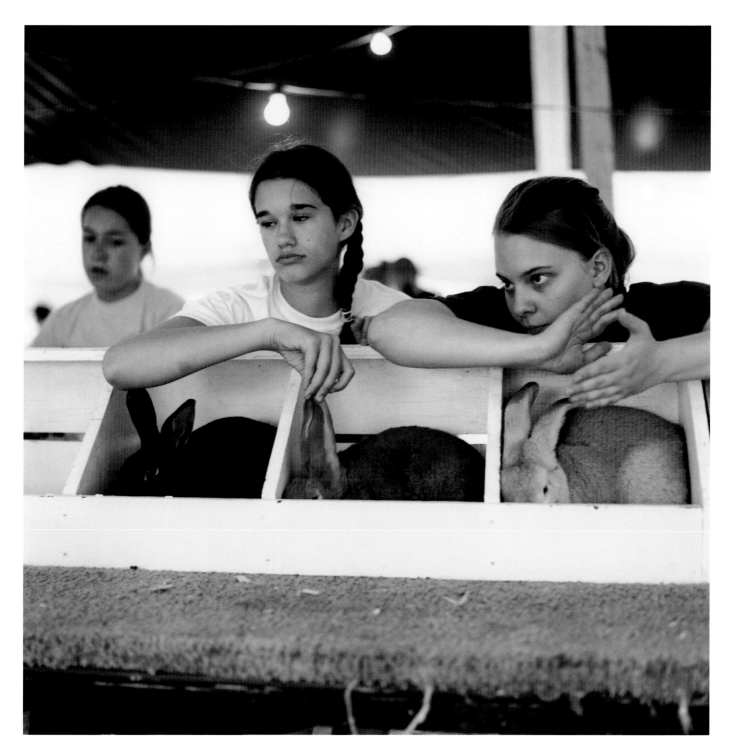

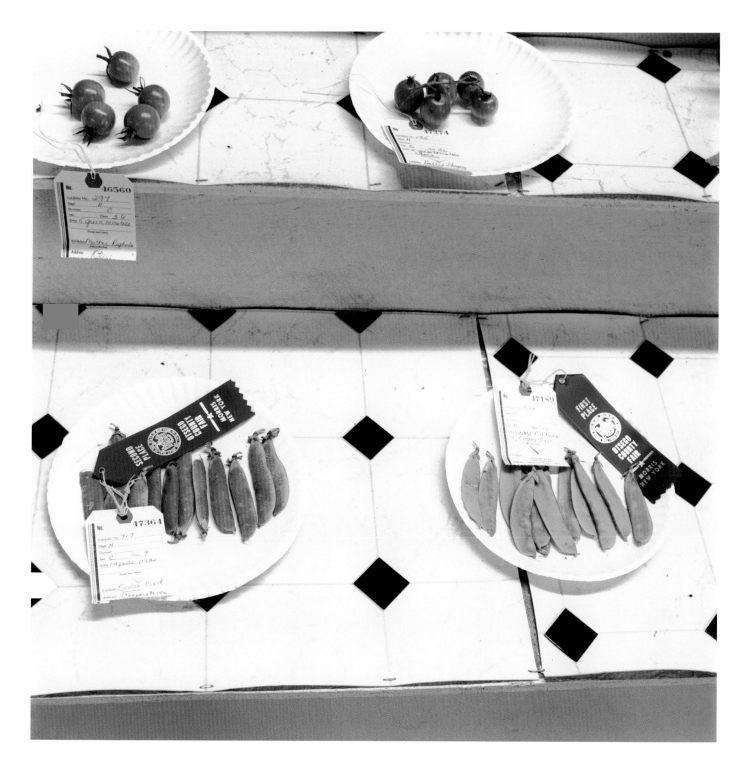

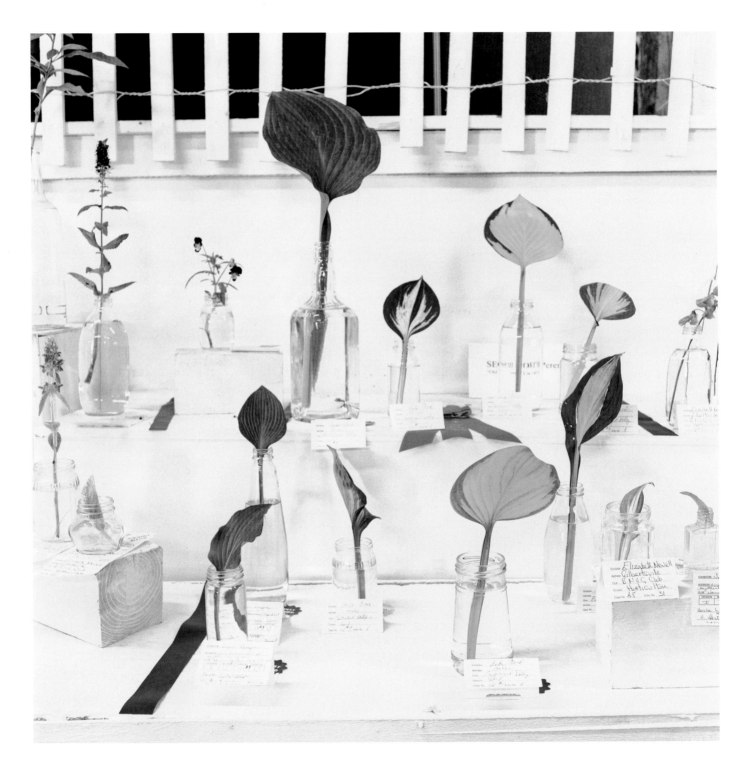

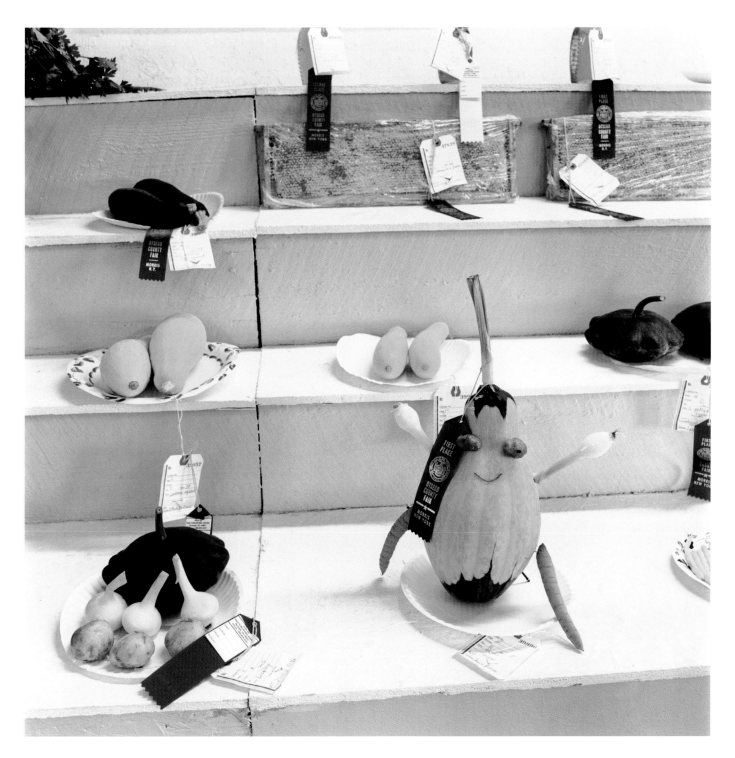

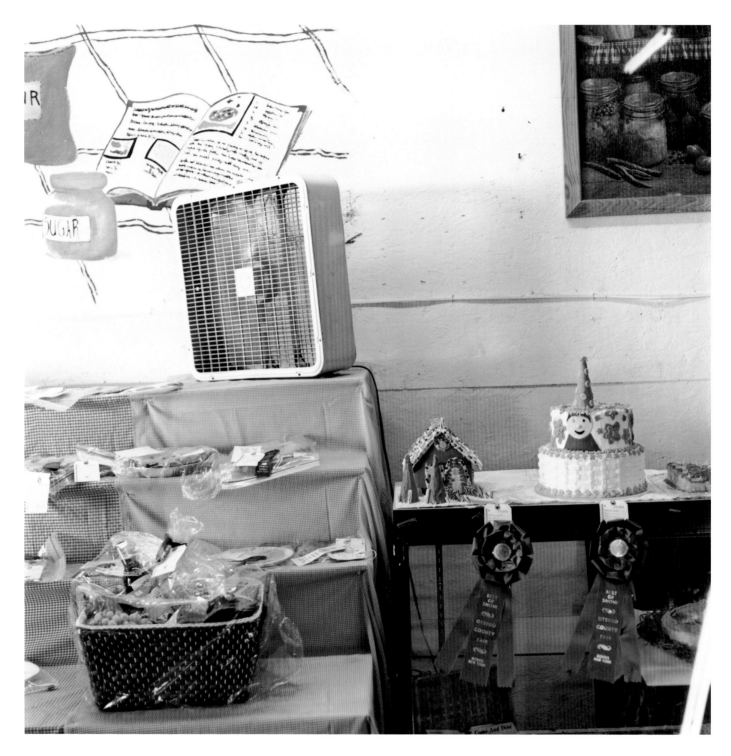

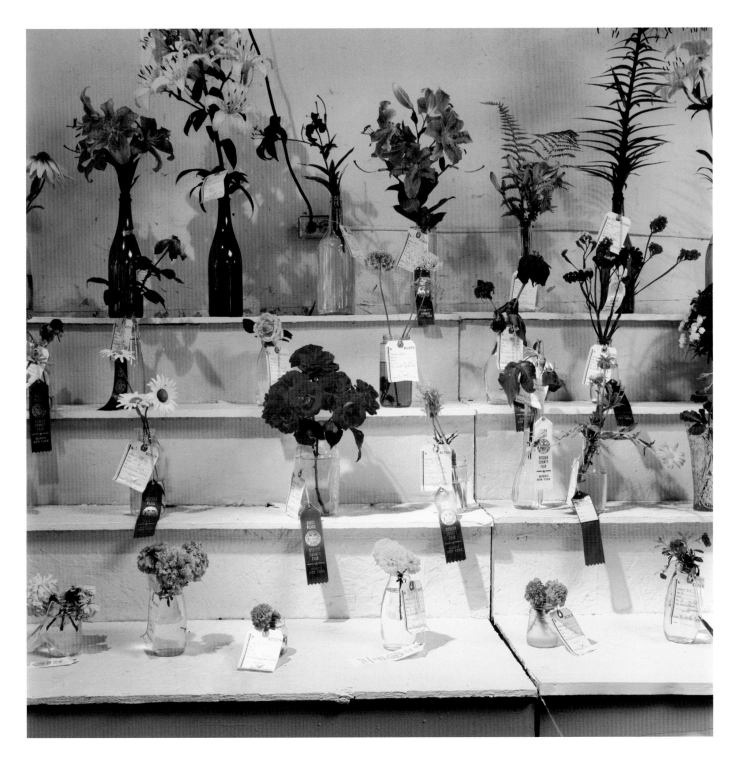

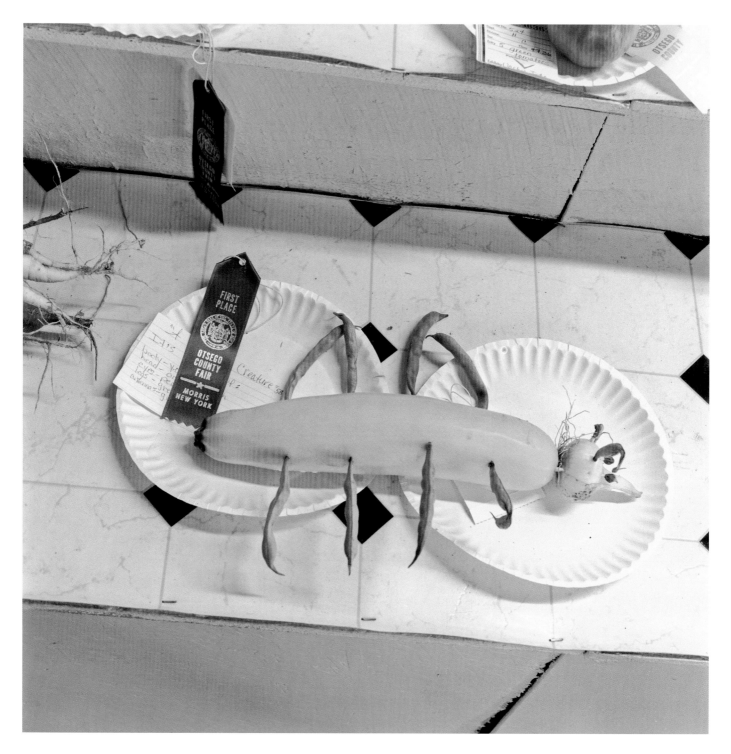

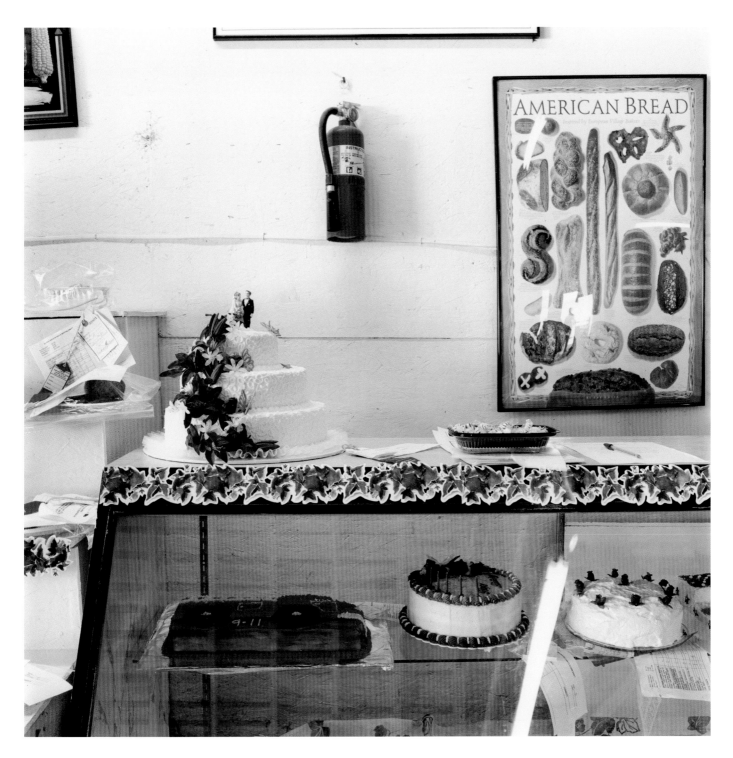

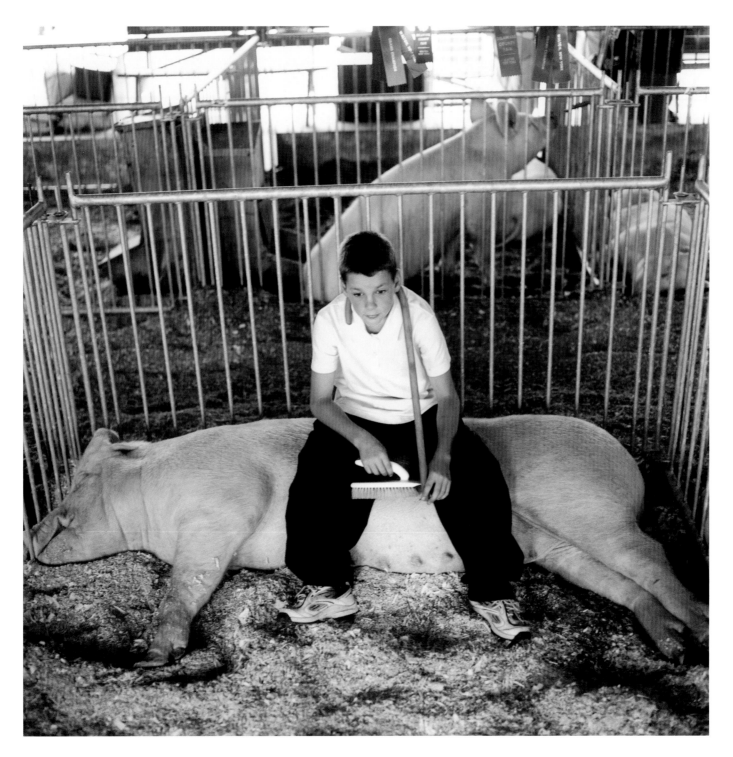

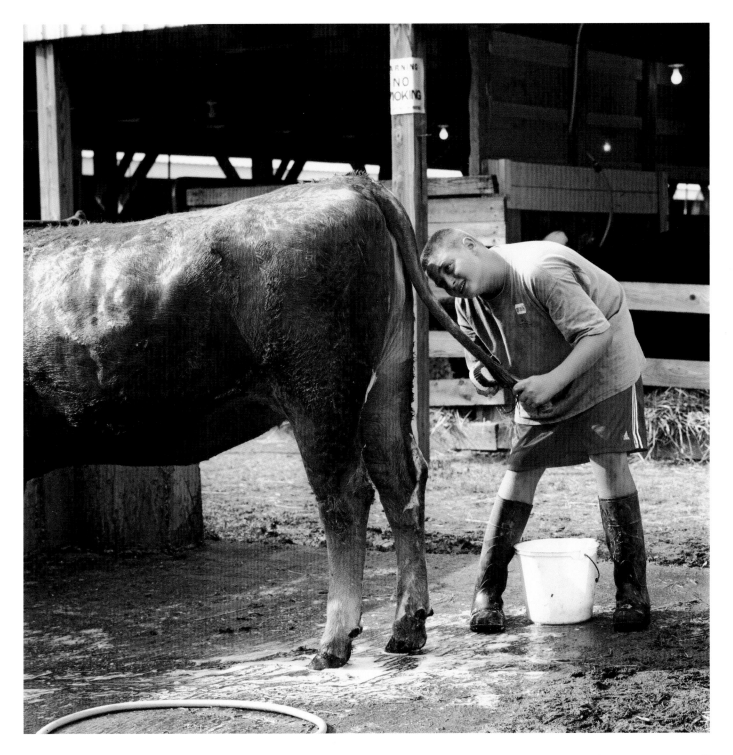

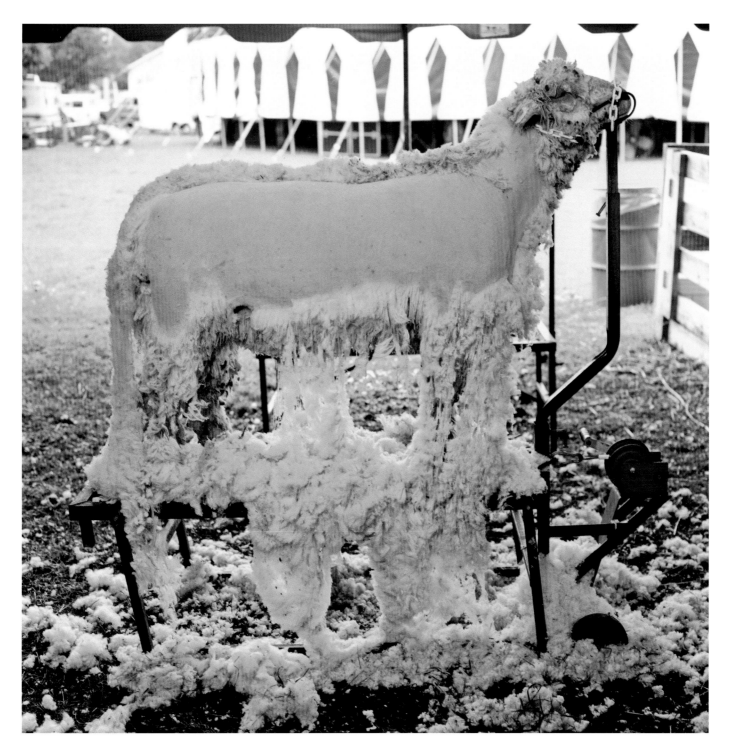

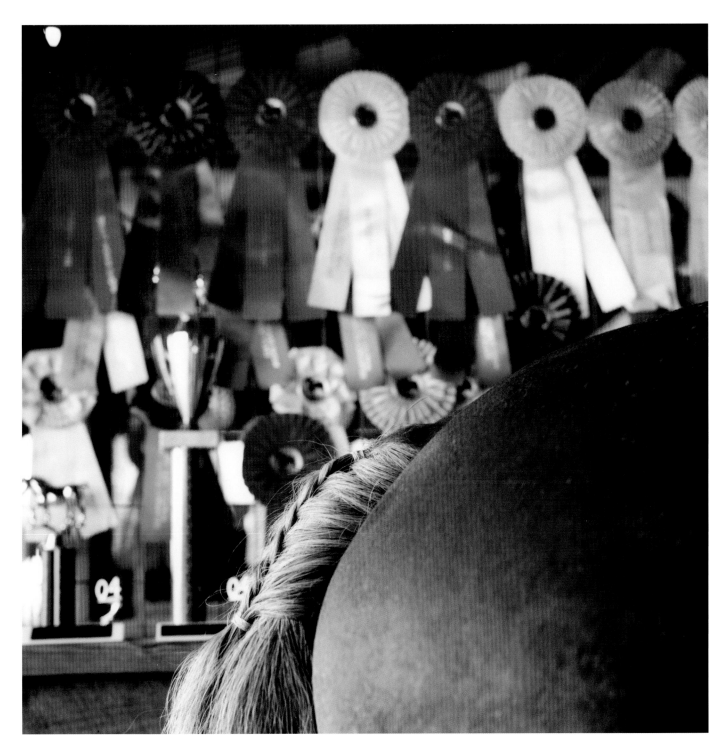

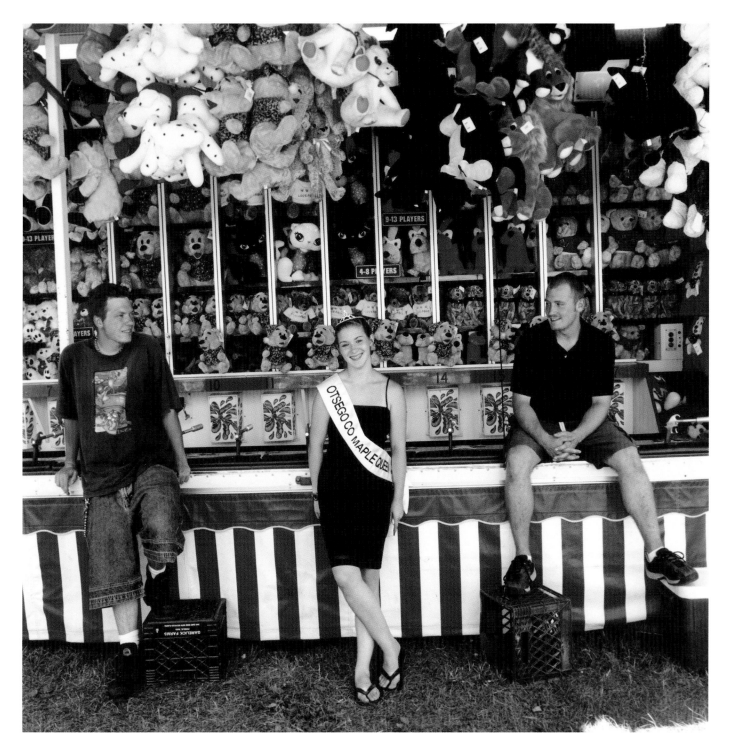

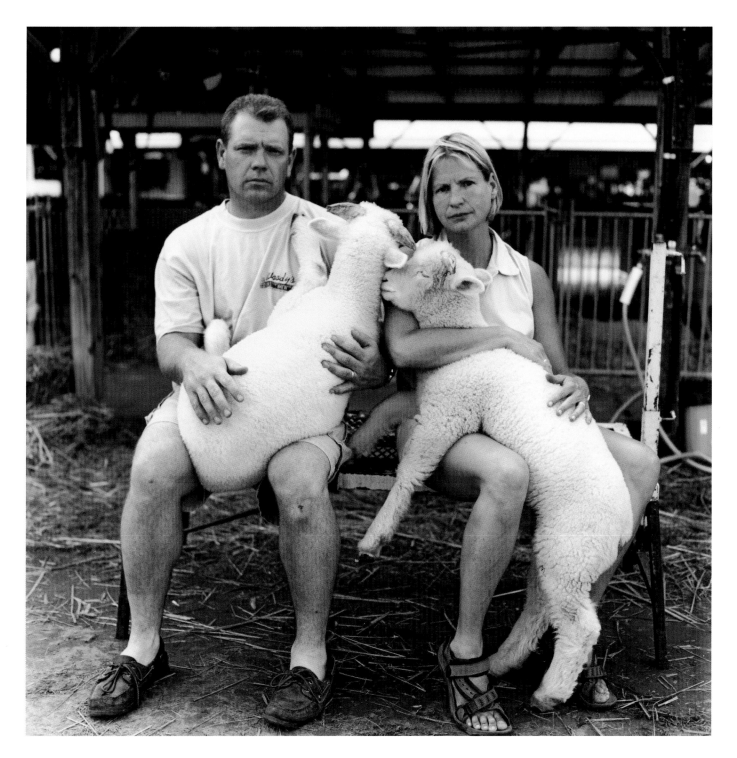

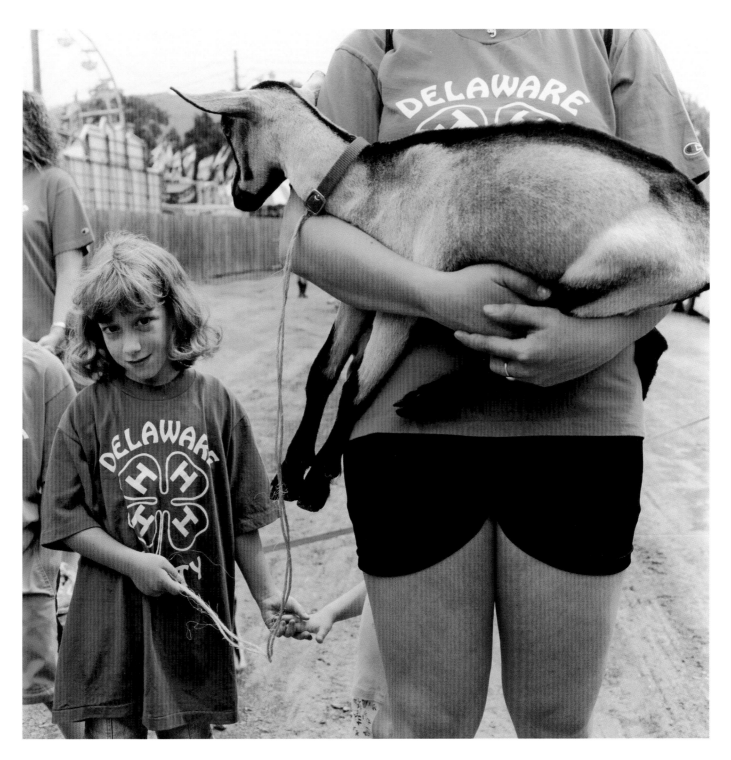

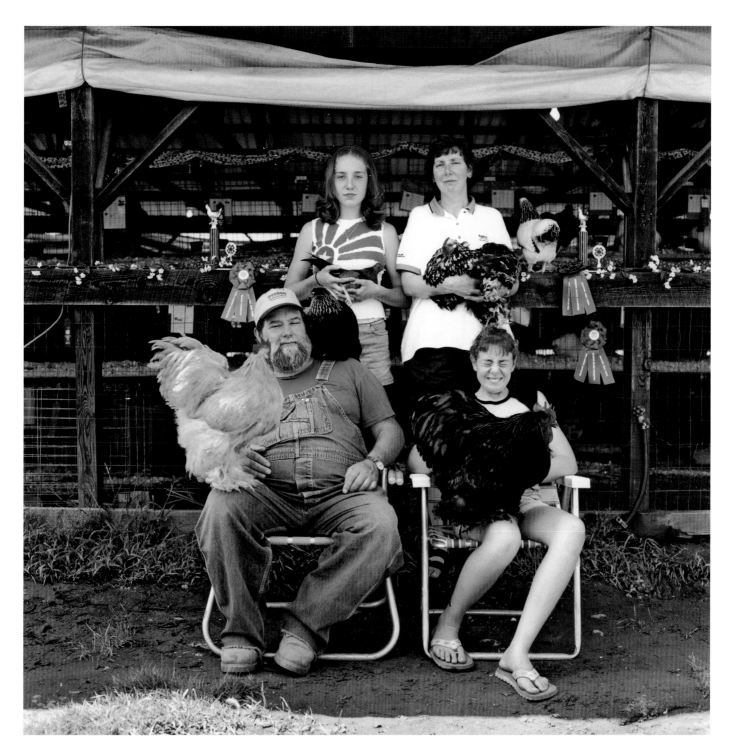

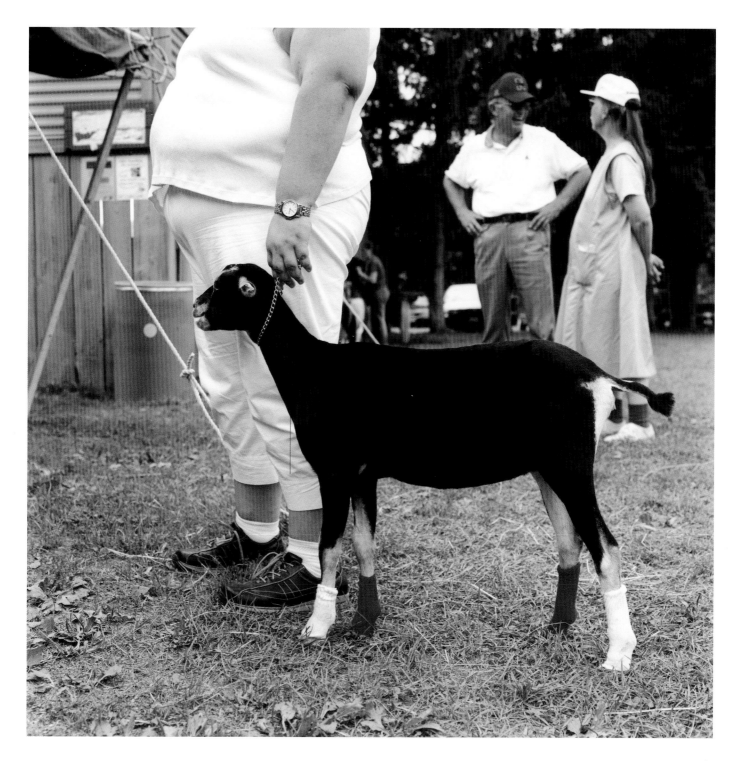

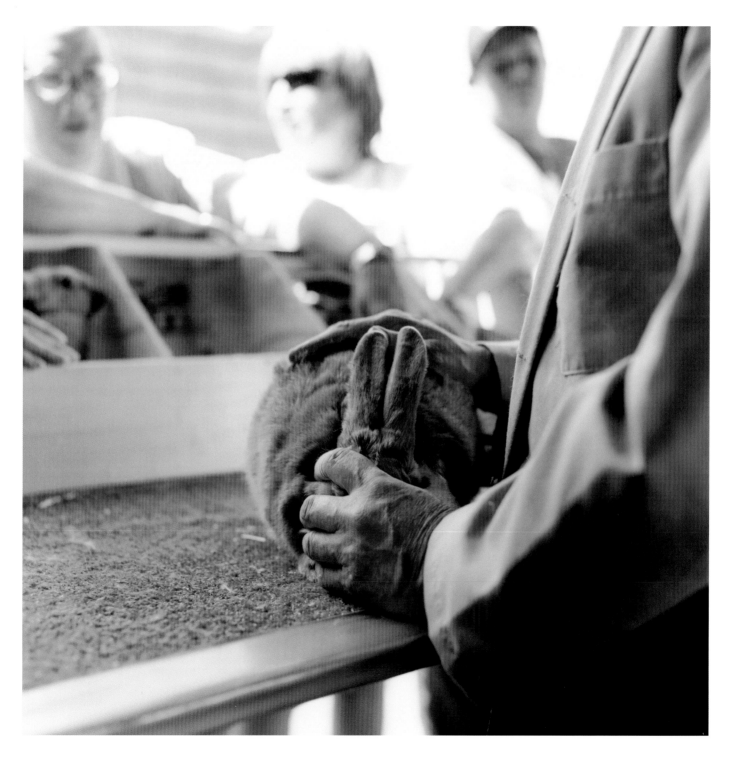

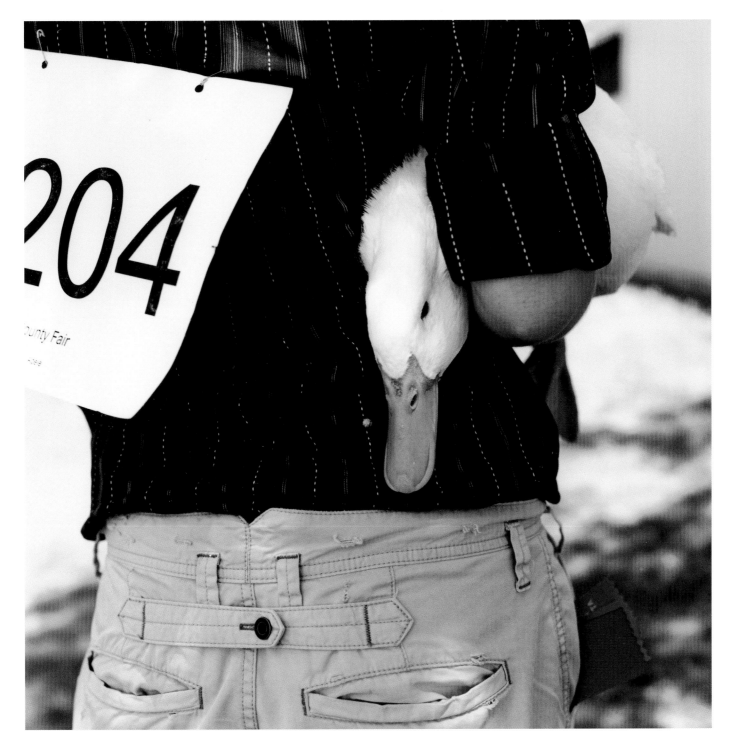

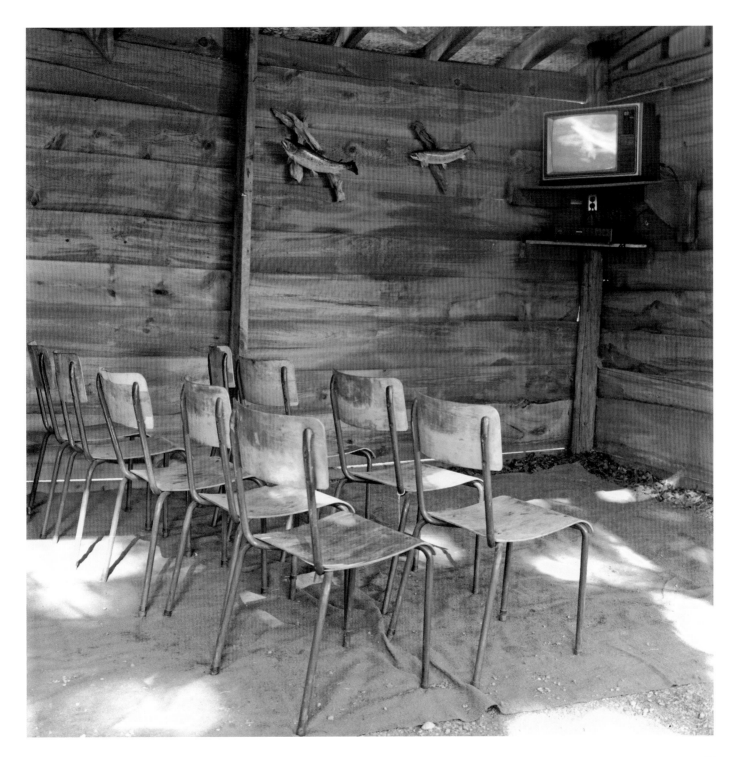

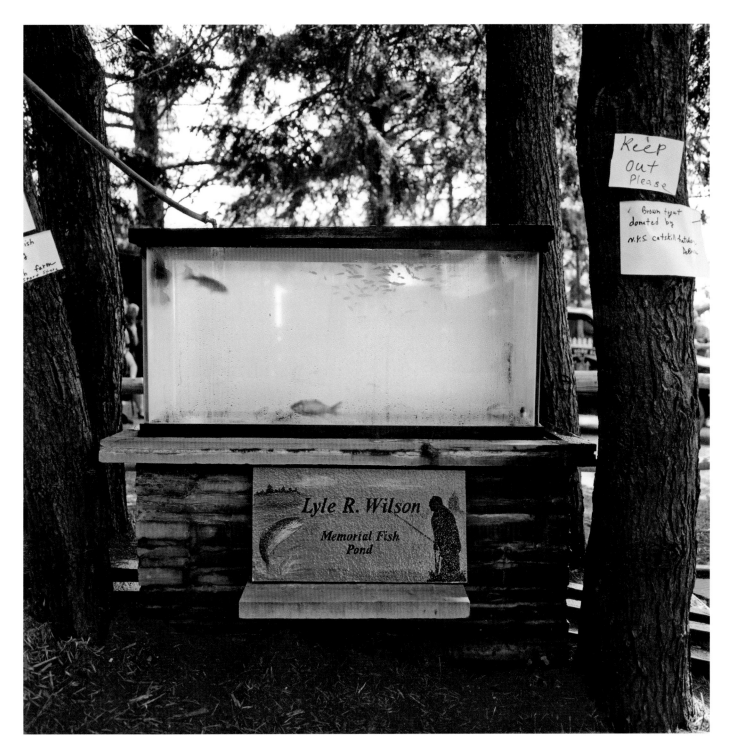

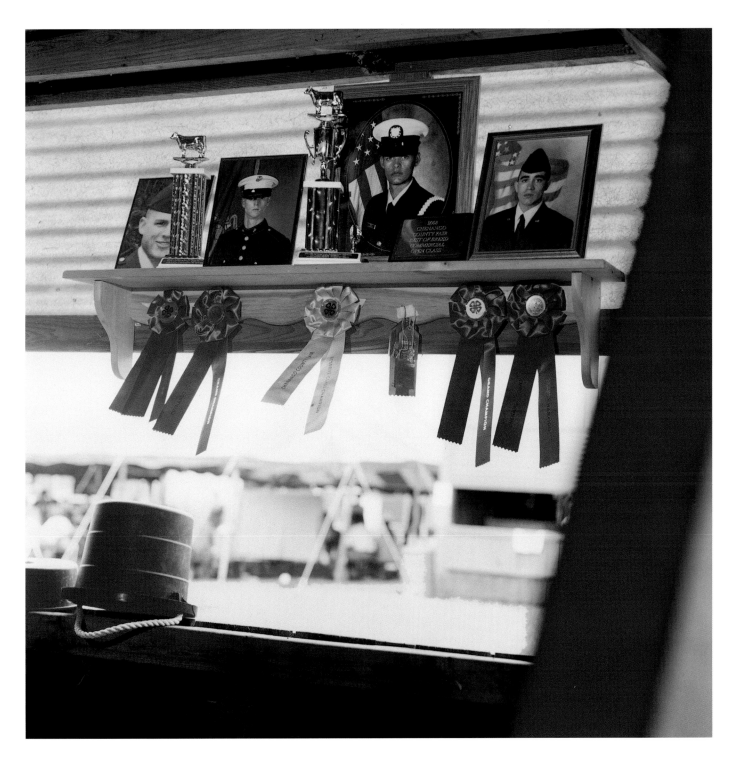

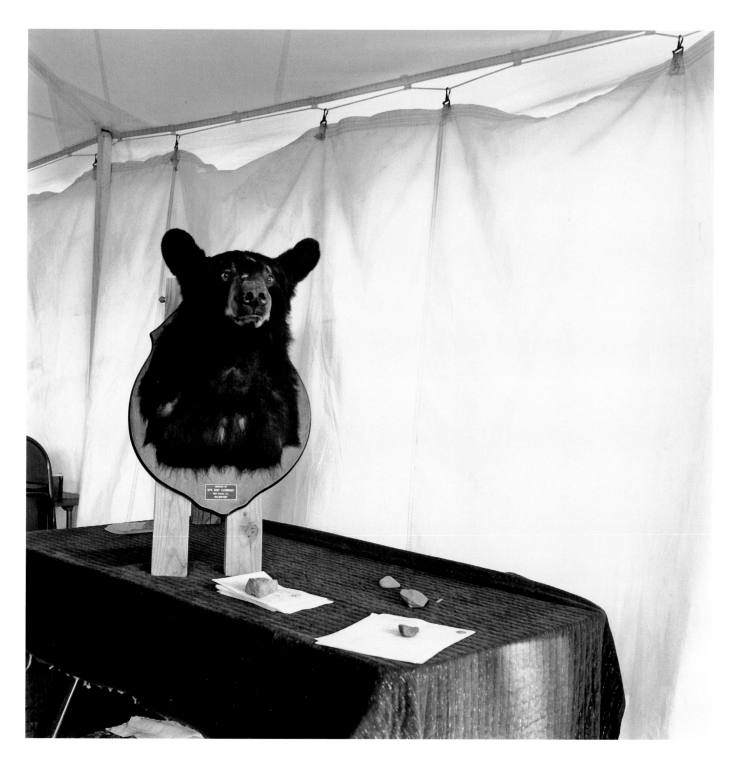

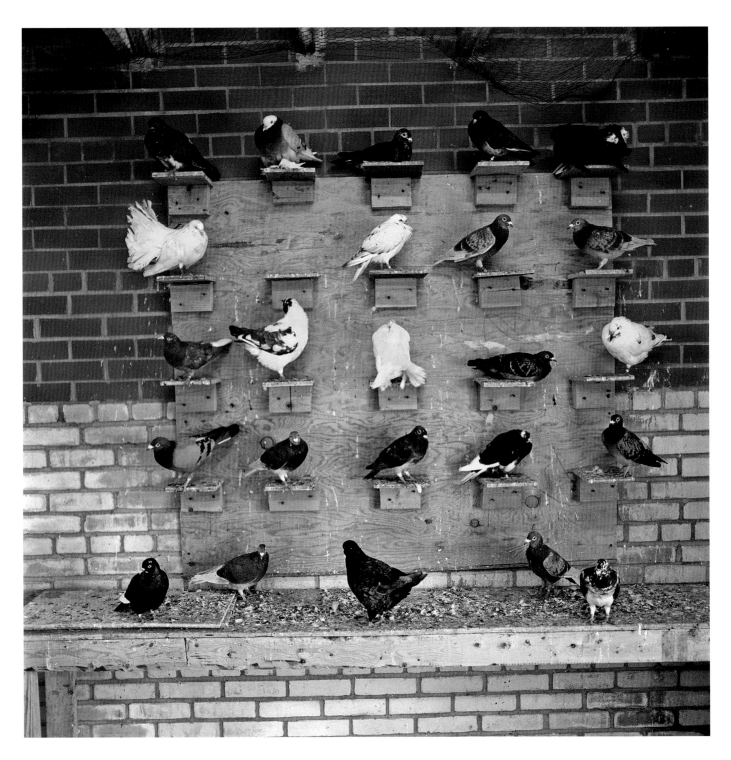

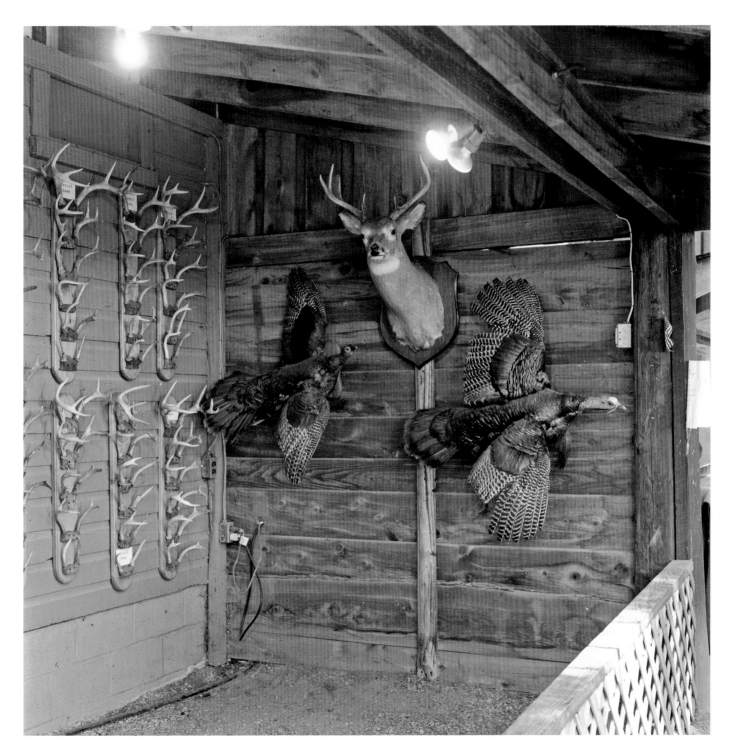

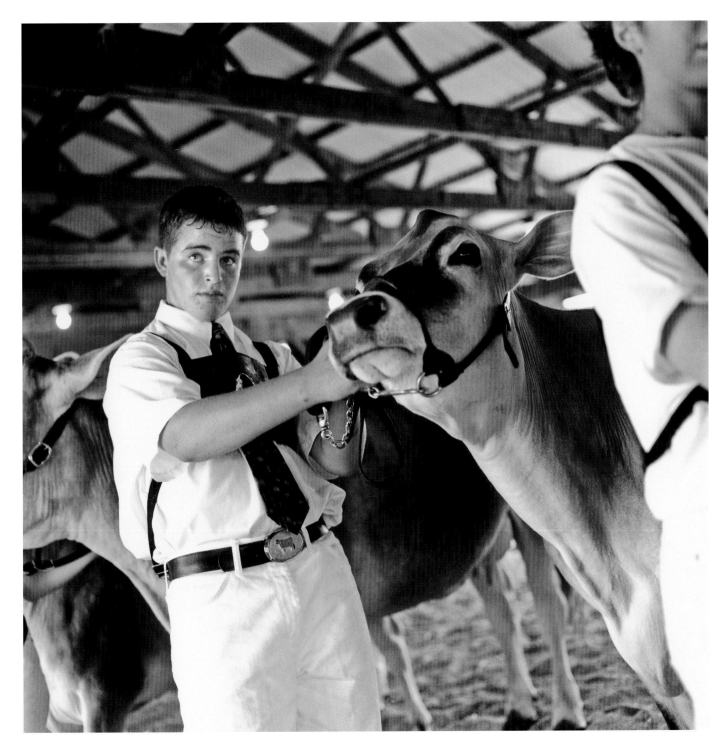

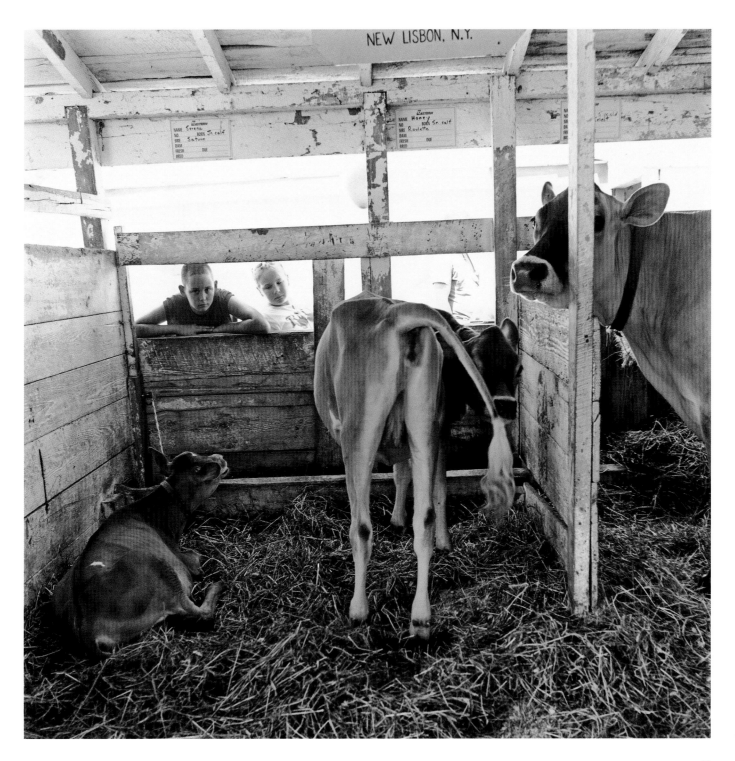

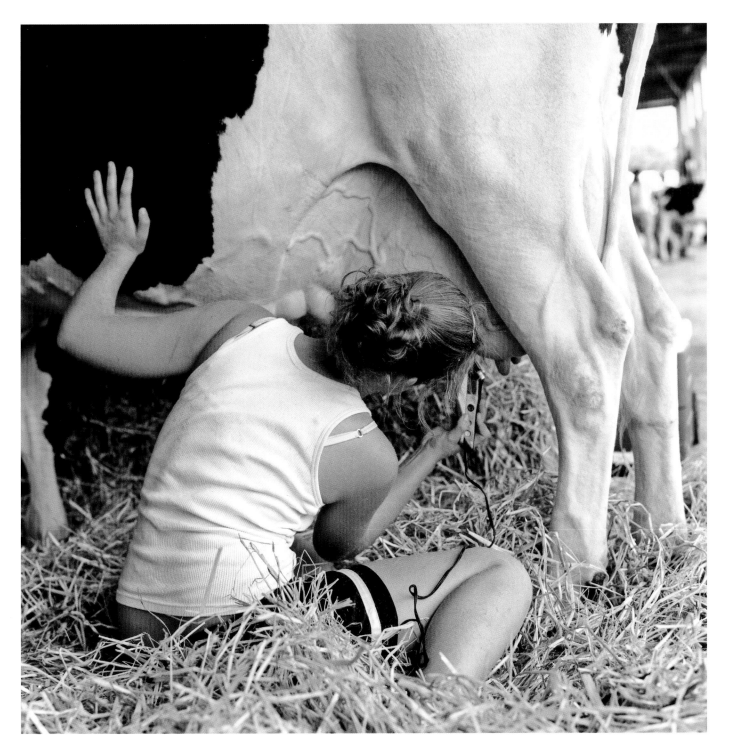

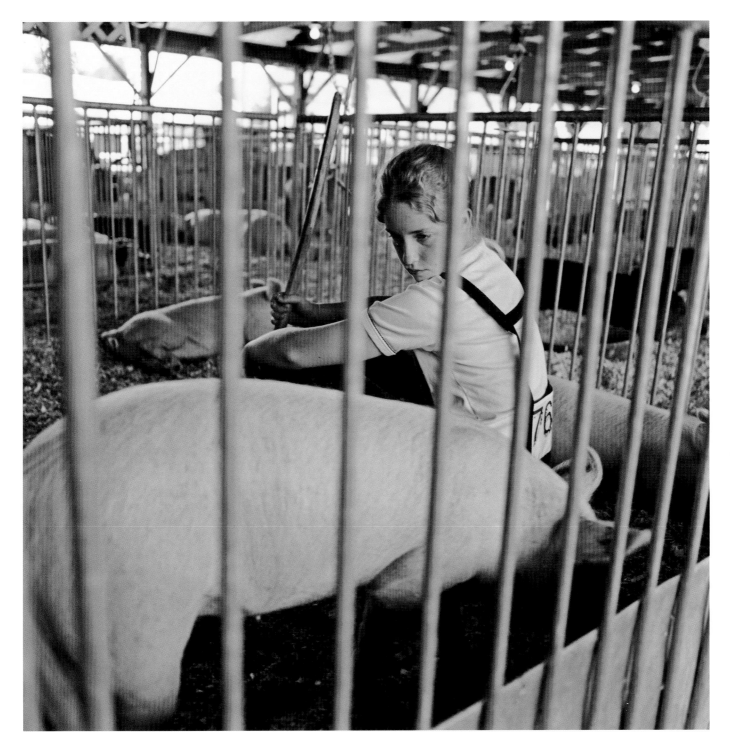

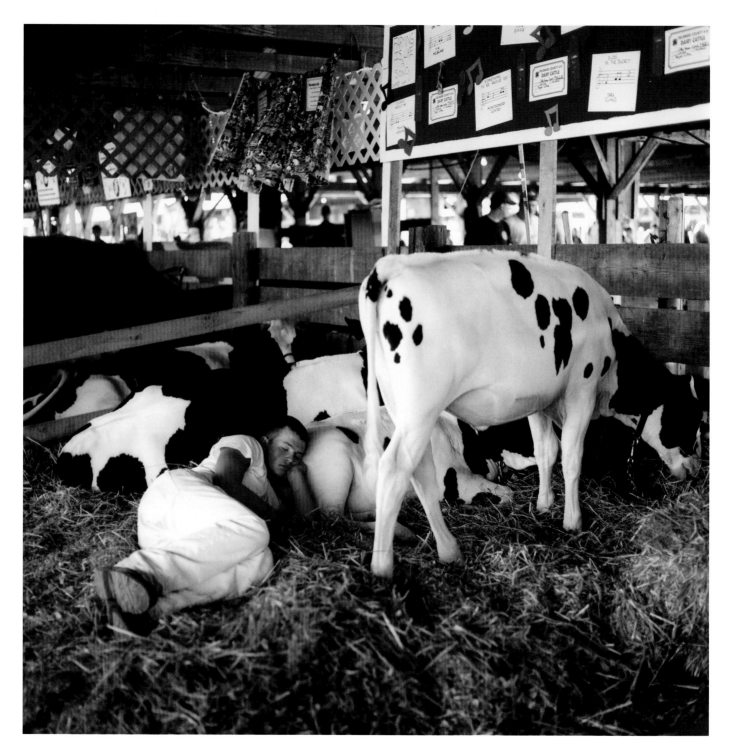

104

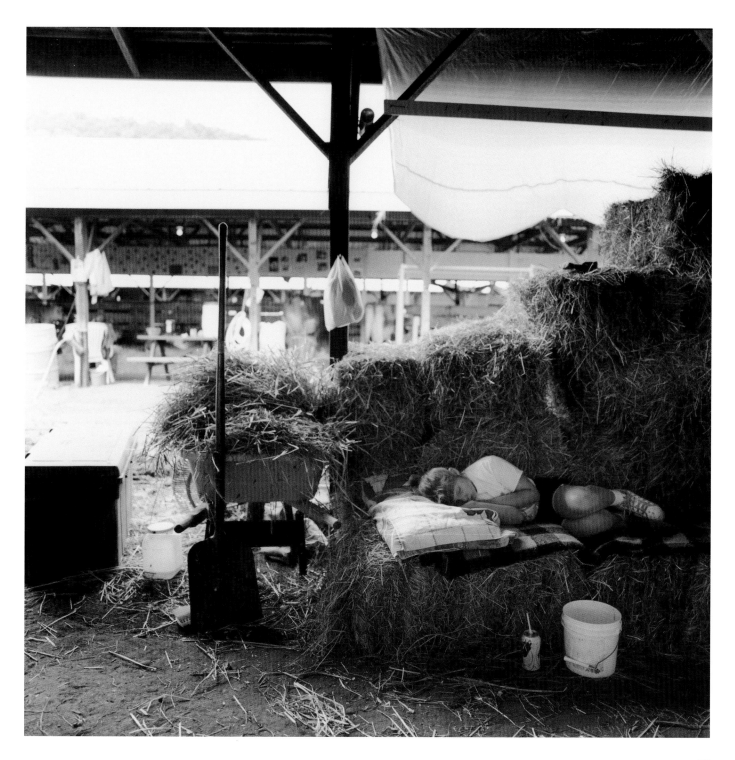

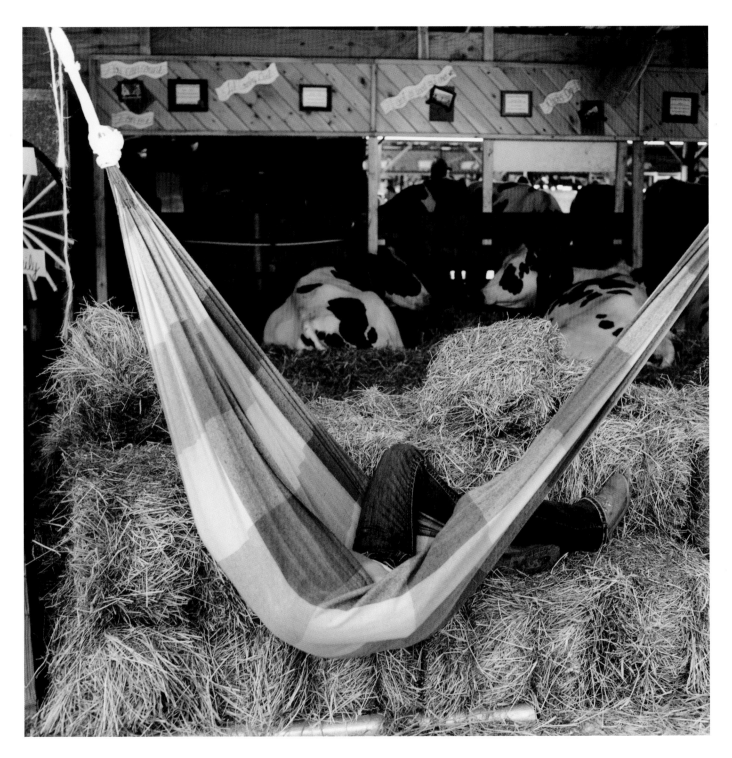

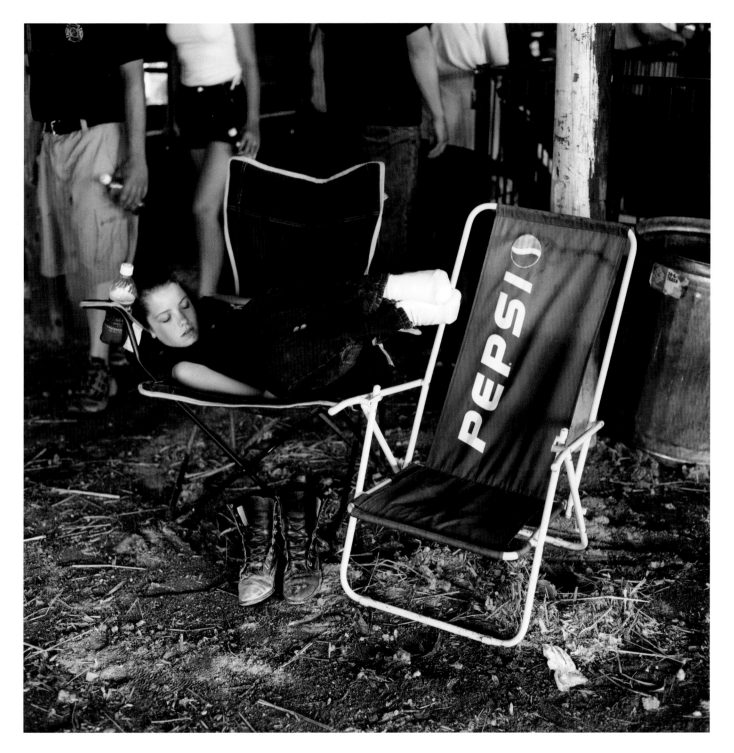

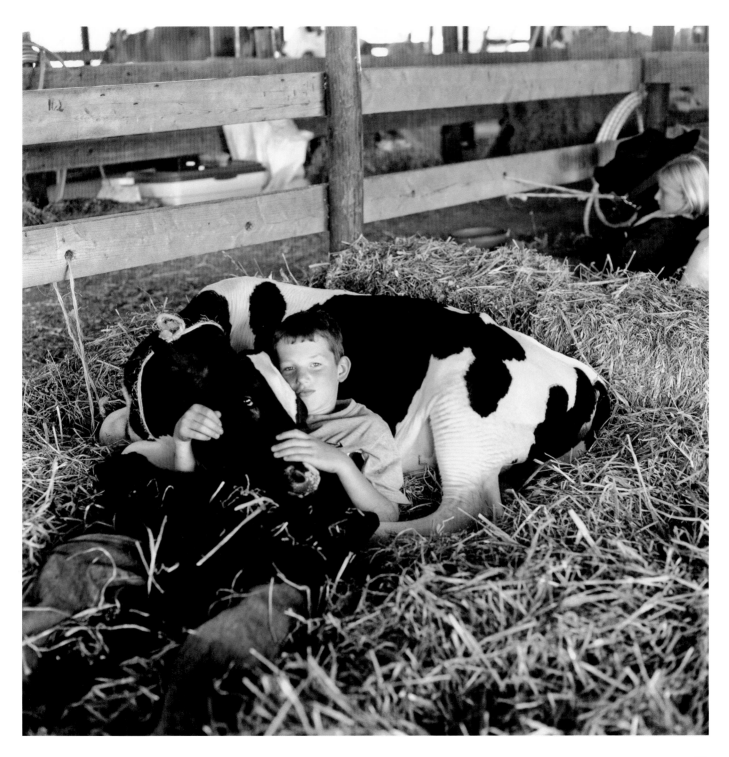

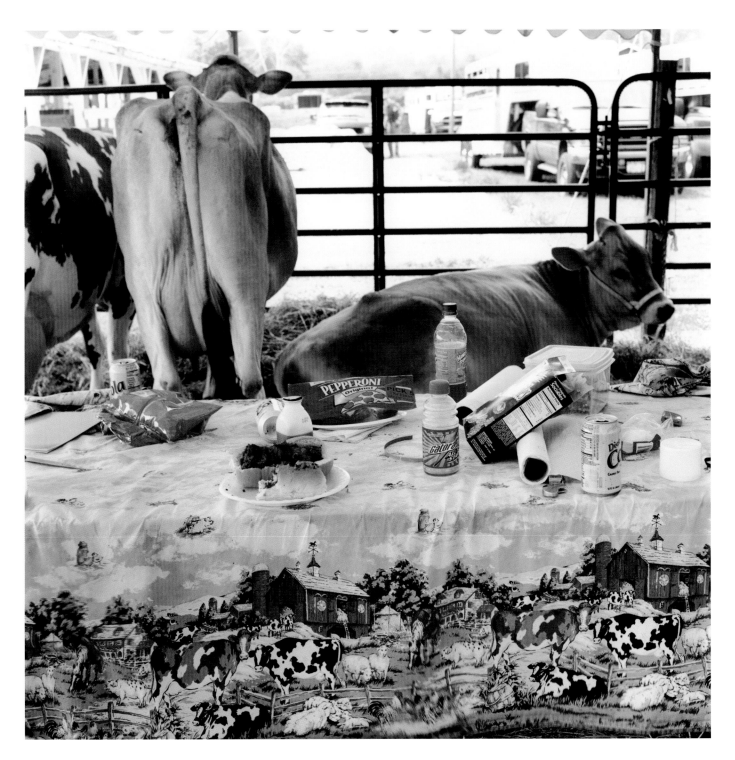

List of Plates

Acknowledgments

I could not have succeeded in this project if it were not for the farm families who befriended me and helped expand my knowledge of their everyday work lives. Particular thanks to all the families who welcomed me, but a special thank you to the Goblet family: Lois, Jim, Justin, Jessica, J.J. and Elizabeth; the Grant family: Deb, Dan, Norie and Mary; the Conklin family: Beth, Donald, Jonathan, Sammie, and Benjamin; the Borst family: Jesse, Terri, Jeremiah and Zachariah; and the Carey family: Kathy, Chris and Silas.

There were many more individuals who were photographed who did not make it into this volume. I would like to thank them – and their cooperative animals. Without their patience and spirit of generosity, I would not have been able to create this body of work. I would also like to extend my gratitude to Kathy Sherwood and all the 4-H members who were so accommodating.

It is unlikely that these photographs would have been created without the insistence of my dear friend and neighbor Bob Greenhall; he convinced me to attend my first fair, the Delaware County Fair in Walton, New York, which launched this journey.

I extend an appreciation also to my friend Dawn Derrick who, as I began this project, helped point me in a direction that I had not initially considered.

Over the years, this body of work evolved from an interesting distraction to a full-blown photographic project. I owe the eventual outcome to a number of people whose thoughtful critique and encouragement helped guide me: John Bennette, who has always been generous with his time and curatorial knowledge; Jenny Liddle and The Roxbury Arts Group who first exhibited this work; Michael Blakeney, Brian Sisco, Eve and Stephen Schaub, who were early supporters; as well as Dawn Barber

and Dom Michel; Patricia and Russell Davis; Peter Firth; Myrna Greenhall; Amy Metnick; James O'Connor; Hilary Snell; and Jane Stine.

I would also like to acknowledge and thank the many reviewers at FotoFest who gave me the benefit of their criticism and encouragement, among them: Hans Michael Koetzle of Leica World, Christopher Rauschenberg of Blue Sky Gallery, Tina Schelhorn of Galerie Lichtblick, and Manfred Zollner of FotoMagazine. In addition several friends and colleagues helped me complete this project: Tony Jannetti, Thomas Kellner, Leah Lococo, Jen Pressley and Mary Virginia Swanson.

I am especially indebted to Roy Flukinger of the Harry Ransom Humanities Research Center at The University of Texas for his essay. His heartfelt contribution emboldens my work immeasurably. I am grateful for his insights and friendship.

The creative staff at Kehrer Verlag, especially, Barbara Karpf, Klaus Kehrer, Jürgen Hofmann, Katharina Stumpf and Petra Wagner were instrumental in making this book come alive, and I thank them for their thoughtful contributions.

I wish to thank my parents, Alfred and Miriam Nelken, for loving and supporting me in whatever endeavor I pursued, and also my daughters, Ada and Nina, for always being an inspiration.

My final appreciation goes to my wife, Adele Q. Brown, who accompanied me to almost every fair. Her patience, gregarious personality, intelligence, and most of all her sense of humor, were an integral part in helping me take this project to its successful conclusion.

Adele, thank you.

Dan Nelken

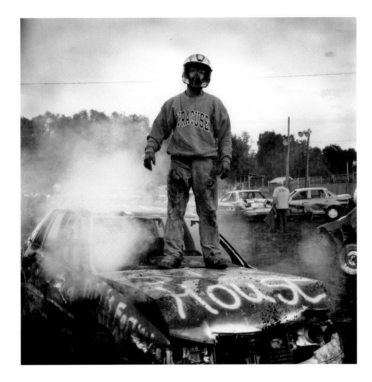

© 2008 Dan Nelken, Roy Flukinger
and Kehrer Verlag Heidelberg

Texts: Roy Flukinger, Dan Nelken
Design and production: Kehrer Design Heidelberg
(Katharina Stumpf et al.)
Image processing: Kehrer Design Heidelberg (Jürgen Hofmann)
Proofreading: Barbara Karpf

Front cover illustration: They Both Won, 2003
Back cover illustration: Two Days Old, 2001

Printed in Germany

Bibliographic information published by the Deutsche Nationalbibliothek
The Deutsche Nationalbibliothek lists this publication in the Deutsche
Nationalbibliografie; detailed bibliographic data are available
in the internet at http://dnb.d-nb.de.

www.dannelken.com
www.kehrerverlag.com

ISBN 978-3-939 583-87-5
Kehrer Verlag Heidelberg